MW00327741

IMAGES
of America

EASTERN
LAPEER COUNTY

The register of deeds during the late 1700s and early 1800s was the future president of the United States, Andrew Jackson. Many of the first settlers in Almont had land grants signed by him. (Courtesy of Ronald Bristol.)

ON THE COVER: Haying season united neighbors and often turned into fellowship. As told in the 1884 edition of *History of Lapeer County*, "Teams were hitched together for breaking up; in harvest time, the neighbors cradled and raked and bound for each other; when one went to the mill he went for the neighborhood; logging-bees and husking-bees, quilting-bees and raisings were play-spells." Until 1846, the township was called Bristol and the village was called Newburg. In the early spring of 1846, it was changed to Almont. (Courtesy of the Almont Historical Society.)

IMAGES
of America
EASTERN
LAPEER COUNTY

Catherine Ulrich Brakefield

ARCADIA
PUBLISHING

Copyright © 2014 by Catherine Ulrich Brakefield
ISBN 978-1-4671-1139-3

Published by Arcadia Publishing
Charleston, South Carolina

Printed in the United States of America

Library of Congress Control Number: 2013944809

For all general information, please contact Arcadia Publishing:
Telephone 843-853-2070
Fax 843-853-0044
E-mail sales@arcadiapublishing.com
For customer service and orders:
Toll-Free 1-888-313-2665

Visit us on the Internet at www.arcadiapublishing.com

*This book is dedicated to the people who preserved the
history of the early years of Eastern Lapeer County
for this and future generations to learn from.*

CONTENTS

ACKNOWLEDGMENTS

This book would not have been possible without the support of those individuals who donated their pictures, knowledge, and experiences.

The idea for this book began in 2007 when I met William Bristol of Brookwood Farms and he showed me the family's museum. A special thanks goes to Ronald and Phillis Bristol and William's son Charles Bristol.

I wish to thank Bill Rykhus, president of the Lapeer County Historical Society (LCHS), for his continued support. My sincere appreciation goes to the president of the Almont Historical Society (AHS), Sheleen Henshaw. Her encouragement hurtled me over the rough moments.

For sharing their heritage with me, I wish to thank Paul Bowman, Gertie Brooks, and Yvonne Uhlianuk.

A special thanks goes to Karen Boecker, president of the Dryden Historical Society (DHS). Her exuberance and willingness to share made my work easier.

Thanks go to JoAnn Welke, president of North Branch Historical Society (NBHS); Preston Orr, for his timeless memories; Kelly Martin, for his expertise about "death's door;" and Fred Crawford, for a glimpse into North Branch's love for baseball.

Thanks also go to Floyd Klauka, president of the Columbiaville Historical Society (CHS), for generously contributing his hours, and to Michael Calvert for sharing his memoirs of the years his family lived in Peter's mansion.

The books and authors that paved the way toward the factual information attained for this volume are: *Pioneer Families and History of Lapeer County, Michigan* by J. Dee Ellis; *History of Lapeer County, Michigan 1884* by H.R. Page & Co.; *The History of Almont, Almont . . . the way it was*, and *Early History, Glaciers in Michigan* by Hildamae Waltz Bowman; *An Octagon for the Curriers* by Melanie Meyers and Frank Angelo; *The Country Gentlemen* and *A Country Club for Country People* by Mary Margaret McBride; *The One Hundredth Anniversary of the House of Worship* by First Congregational Church; *History of Dryden* by Dryden Historical Society; *The Good Old Days* by R.J. McGinnise; *Sesquicentennial North Branch 1855–1980* by North Branch Historical Society; and *A History of the Columbiaville, Michigan Area* by Robert L. Blue, sponsored by Columbiaville Historical Society.

I would like to thank my husband, Edward; my daughter Kimberly Warstler; and my son Derek for their encouragement. To my two grandchildren, Zander and Logan Warstler, I bequeath my prayer that this book will enlighten you as it did me. I pray that all who read *Eastern Lapeer County* will learn about their American heritage not often acknowledged within the pages of a history book.

INTRODUCTION

Capt. Bezaleel Bristol of the Connecticut Militia watched with satisfaction as the British soldiers' bright red coats flapped in the breeze of their retreat in 1777. The Treaty of Paris in 1783 formally ended the Revolutionary War for the 13 colonies and extended American boundaries from the Atlantic coast to the Mississippi River and from the Great Lakes to the 31st parallel in the south, thus opening the Northwest Territory.

The Northwest Territory gave soldiers and settlers a chance to become land owners. Register of deeds and future president of the United States Andrew Jackson's signature can be seen on many of these early land contracts.

Settlers began migrating into Michigan's wilderness with the building of the Erie Canal in the 1820s that connected the Atlantic Ocean with the Great Lakes. Congress realized it knew little about Michigan's northern region and sent the first surveyor, Joseph Wampler, in 1822. As told in *Early History, Glaciers in Michigan*, Wampler wrote that "Michigan is a horrid place. Only mosquitoes, bull frogs and Indians could live there." In January 1834, Capt. Harvey Parke of Pontiac undertook the completion of Wampler's job. The snow was 18 inches deep. The streams were not frozen over and the swampy area and marshes made travel slow. Failing to reach the headquarters of the survey party, which was in Lapeer at the time, Parke and his crew spent the night in the woods without food, tents, or blankets. One surveyor named M.B. Smith described their nighttime ordeal: "We laid poles down and then piled hemlock boughs on top to keep out of the water while we slept." Finally reaching Lapeer, the men attempted to do their survey work. Because of the weather, they were forced to return home in April and decided to wait until autumn to resume. In February of 1835, they completed their mission.

Wilderness trails were marked from Romeo to what would later become Almont and Lapeer County by early explorers with "blazed" trees.

James Deneen carved out the first trail and settled in what would later become Lapeer County and the town of Almont in 1828. He and his family lived alone in the isolated wilderness for two years.

One of the earlier settlers of Dryden, Mr. Squire, recalls in his memoirs using Deneen's trail in 1830. Oliver Bristol had a frame up for a house, but it was not yet enclosed. There was a log house built by Mr. Sleeper and the village of Almont was just a vast forest.

The Scottish began the first settlement of Lapeer County, known today as the Scotch Settlement. As recorded in *Pioneer Families and History of Lapeer County* and *The One Hundredth Anniversary of the House of Worship*, their strong religious principles and a "high order of civilization was introduced into this new country by the early settlers . . . who brought with them a high appreciation of the worth of a Christian intelligence."

Mary Ann Ingalls Bristol recorded in her memoirs the 1836 great migration to Michigan by steamboat down the Erie Canal. Landing in Detroit, Mary learned of the "great rains." Outside the city, water flooded the road for three miles, nearly up to the lumber box on their wagon.

During those early days in Almont, it was not uncommon to see Indian women riding into the settlement on their ponies with a papoose strapped to their backs and two large willow baskets dangling on each side of their horse's flanks. Their furs and buckskins would be traded at John Robert's trading post for blankets and tobacco.

The Chippewa and Huron Indians were an athletic people. One Huron Indian named Tip-si-co could outrun any horse-drawn wagon and liked to wear the white man's clothing, often donning a black silk hat for special occasions. He could cradle, rake, and bind just as well as any farmer, and every farmer was very glad to see his paint pony gallop towards them in the field when the work was plentiful and workers were few.

Before the pioneers' ax could stop ringing through the forests, the traveling preacher was riding his horse down the wagon-rutted path. His weathered face crinkled into a grin as the young people of Bristol (later called Almont) hurriedly proposed to their sweethearts. Then the weddings, christenings, and funerals would occur. David Ingalls's 13-month-old daughter died on the way to the Bristol settlement. Bezaleel Bristol's infant son died at the settlement in 1829.

Cabin doors opened and caring hands reached out to the bereaved and travel-weary pioneers searching for a new beginning in the fertile farmlands of Michigan. Indians found their way to settlers' doorsteps, never knocking. They just walked in and sat down beside the warm fireplace when they were cold and wet and their hunting trip proved futile. The settlers never turned anyone away and no one ever left hungry.

The term "hospitality" took on a valiant meaning when Dryden abolitionist Dyke Cooley's home became a station of the Underground Railroad, traveling from the slave states of the South to northern Canada.

The Great Winds came and tore down their structures and these rugged settlers rebuilt again. Towns sprang up, and fires burned them down. Relentlessly, the sweat of settlers' brows helped erect towns and soon the Lapeer County map became dotted with the names of new townships. Eastern capitalists worked their way toward these remote settlements and soon locomotive smoke billowed upwards into the sapphire-blue skies as the railroad and its metal rails zigzagged through meadows and farmlands.

Imlay Township was named for William Imlay, a capitalist who purchased 240 acres around 1830. But it was not until 1850 that Imlay Township was separated from Almont and the first train began running into Imlay City in 1870.

A love-struck German immigrant named William Peter woke up the sleepy town of Columbiaville and proved that when a man followed his heart, he could achieve anything.

Human exploits shook Eastern Lapeer County when orphaned George Owen Squier received an appointment to West Point. He became a student of physics at Johns Hopkins University while stationed at Fort McHenry. Nine years later, Squier discovered "wired wireless." When the Spanish-American War erupted in 1898, Squier served in the Philippines, and when World War I broke out in Europe, Squier aided stranded tourists to get them safely out of Europe.

American patriots responded with a vengeance after the bombing of Pearl Harbor. Columbiaville cadet Ron Seamers and Lt. Carl Hibbert grabbed their aviator equipment and jumped into the cockpits of the mighty flying fortresses that were B-17s.

Five generations of Eastern Lapeer County residents continue to live here. Names like Bristol, Bowman, Orr, and Crawford have not left these fertile hills.

Travel through these snapshots of history, back to when life was simple. Travel back to when Christian values were a basic part of life and death, and to when strangers were greeted country-style, as the panoramic view of *Eastern Lapeer County* comes alive with history, heritage, and hospitality.

One

PIONEERS

Tip-si-co would bet settlers he could make it to Lapeer before they could. The wagons sped down the roads while Tip-si-co hurdled fences and gullies and beat them. Tip-si-co owned a paint horse and would take it by the tail and lash it into a run and jump up, landing on the horse's rump. Photographed during Old-Home Week between July 29 and August 1, 1909, is Michael Altiman (left) and Tip-si-co (right). (Courtesy of Paul Bowman.)

Capt. Bezaleel Bristol of the Connecticut Militia acquired a land grant of 80 acres in Section 33 signed by Register of Deeds Andrew Jackson. On May 22, 1831, his grandson, Bezaleel Bristol (1782–1859) brought his wife, Olive Gillett, and sons Joseph and Sheldon to the frontier settlement of what became Almont. (Courtesy of Phillis Bristol.)

David Ingalls was born in 1796. He and his wife, Betsy, came to Almont, Michigan, from New York in 1836. Ingalls received his land grant from the US government in 1829, which included property on both sides of Van Dyke, Boardman, and Hough Roads. Ingalls's deed was signed by Andrew Jackson. (Courtesy of William Bristol.)

Joseph Bristol remained on his parents' farm located on the east half of southeast quarter section 33. He married Mary Ann Ingalls on June 13, 1847, who was second cousin to Laura Ingalls Wilder. Mary Ann Ingalls Bristol had seven children. In 1849, Bristol bought the west half of the northeast quarter and the northeast quarter of northwest corner section 34. (Courtesy of Phyllis Bristol.)

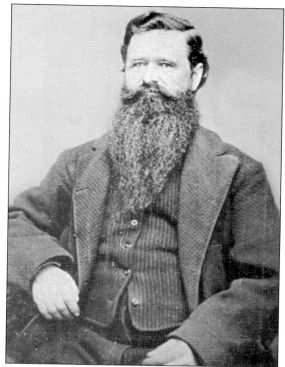

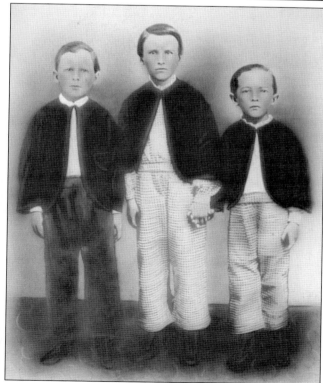

These three brothers were sons of Joseph and Mary Ann Ingalls Bristol. From left to right are Oliver, George, and William Bristol. On March 7, 1834, townships six and seven north (now known as Almont and Imlay) were organized under the name of Bristol in honor of Oliver Bristol, its first supervisor. This image was taken from an original 1864 tintype. (Courtesy of William Bristol.)

11

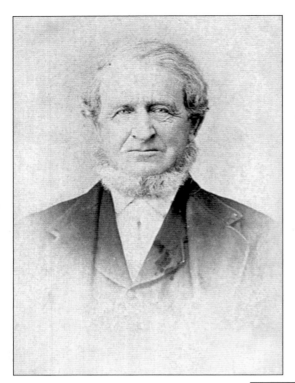

Sheldon Bristol (1816–1892) was 21 years old when he went to work "by the month on his own account," as told in the 1884 edition of *History of Lapeer County*. In 1842, he paid up the debts on a homestead he purchased on the east half of southeast quarter section 33. These early settlers enjoyed the sport of fox hunting. (Courtesy of Phillis Bristol.)

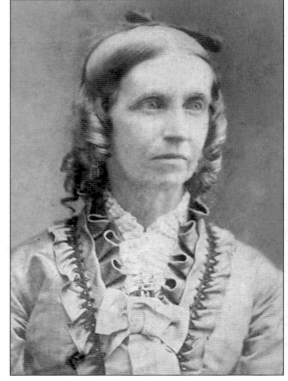

Emily Ingalls Bristol (1820–1892) married the hard-working and love-struck Sheldon Bristol on November 20, 1842. In 1881, he bought the west half of the northwest quarter of section 34—it was 115 acres—and built one of the most beautiful houses in Almont. Emily could not have children of her own, so Mary Ann's son George went to live across the street with his Aunt Emily and Uncle Sheldon. Emily also raised a little girl. (Courtesy of Phillis Bristol.)

George Bristol went to Michigan State College and played in the College Cadet Band. He returned to Almont and married Mary Tosch from Capac. They had two daughters, Teresa, whom they nicknamed Tressie, and Mabel. Mabel and Teresa Bristol were the first women who attended Michigan State Agricultural School. From left to right are Teresa, Mary Tosch Bristol, and Mabel Bristol Yoder. (Courtesy of Phillis Bristol.)

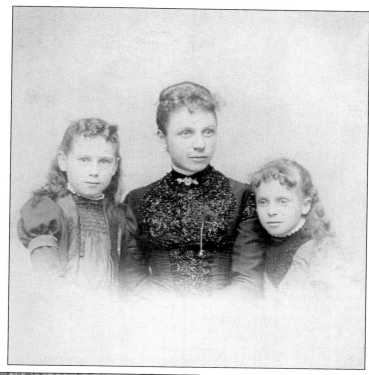

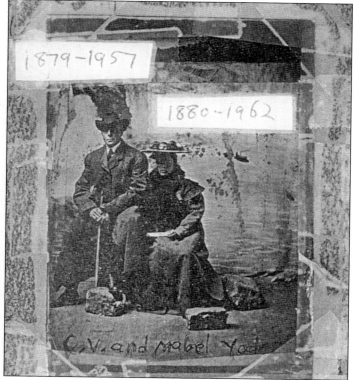

Mabel Bristol married Price Vanderbilt Yoder on October 6, 1904. Price Vanderbilt dropped Price from his name and encouraged the townspeople to call him Commodore Yoder. He acquired the fascination for his new name through his travels to Canada and elsewhere. (Courtesy of Phillis Bristol.)

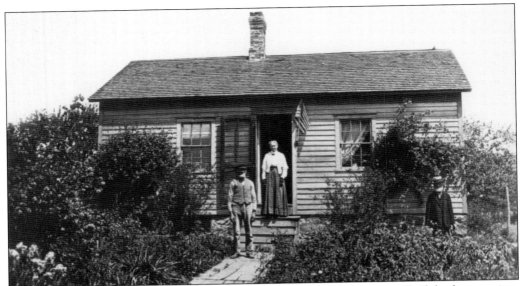

Oliver Bristol, nicknamed "Squire" because he served as a justice of the peace, had the first marriage in this frontier in his cabin when the preacher came to town. On March 7, 1834, townships six and seven north (now known as Almont and Imlay) were organized under the name of Bristol. The name Newburg was adopted for the village. In 1846, the village of Newburg and township of Bristol changed to Almont. Almont is a modification of a Mexican general's name, Juan N. Almonte. (Courtesy of AHS.)

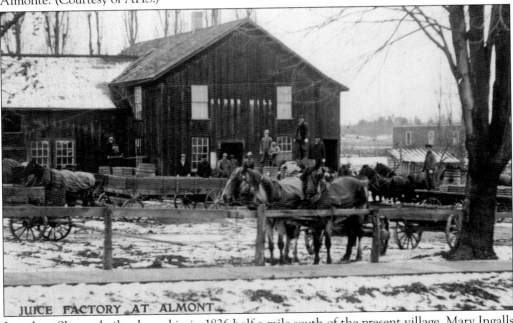

Jonathan Sleeper built a log cabin in 1826 half a mile south of the present village. Mary Ingalls recalled in her memoirs that when her family first came to the settlement, they stayed with Sleeper. He saw a need for a carding and fulling mill where sheepherders could take and market their fleece. Many additions were made; the mill changed hands often and became the Almont Juice factory. (Courtesy of AHS.)

Anna Deneen Walker, born March 15, 1829, was the first white child born in Lapeer County. Her father, James Deneen, was the first settler. Anna inherited the west half of the northeast quarter of section nine. She married Charles Walker, and they had eight children who wore clothes made out of wool from the sheep. After shearing their sheep, Anna took it to the carding mill. It was returned in rolls, and with the aid of her spinning wheel, Anna wove the yarn into flannel and sent it to a factory in Almont to be "pulled." (Courtesy of AHS.)

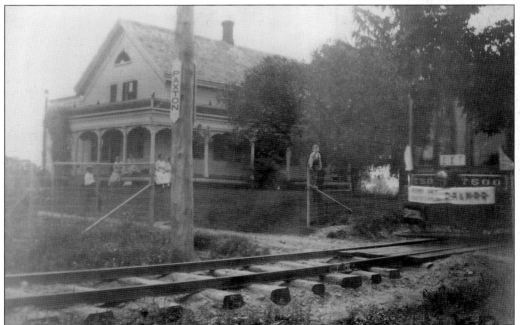

Charles Walker built a two-story house and barn. The house is located on the east end side of Van Dyke, north of Dryden Road, south of Hollow Corners. Anna and her girls wore flannel dresses and pantaloons everyday. If they wanted to look nice, they wore calico. This picture shows the Detroit Urban Railroad in August 1914 going through their front yard. (Courtesy of AHS.)

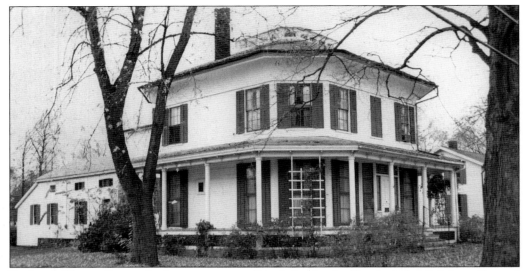

Frederick Plumer Currier built a steam sawmill in Imlay for the Beach, Imlay & Morse Co. and operated a paper mill in Vermont from 1842 to 1845. He settled in Almont in 1846 and built this octagonal house in the 1850s. Currier bought Barrows and Muzy foundry, a machine business where he manufactured furnaces. (Courtesy of AHS.)

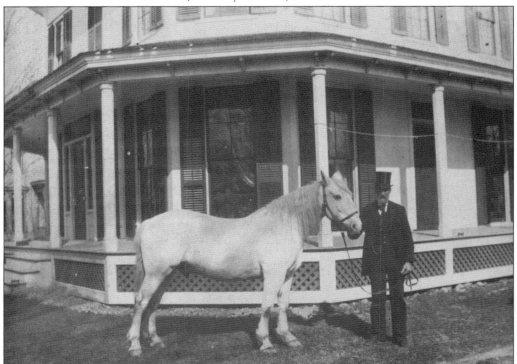

The original furnaces installed in this octagon home were from Currier's foundry. Frederick stands proudly alongside his favorite horse in front of his home at 231 East St. Clair Avenue. Four County Community Foundation, a nonprofit organization first founded to raise money for a local hospital, presently owns the home that was family owned for 61 years. (Courtesy of Paul Bowman.)

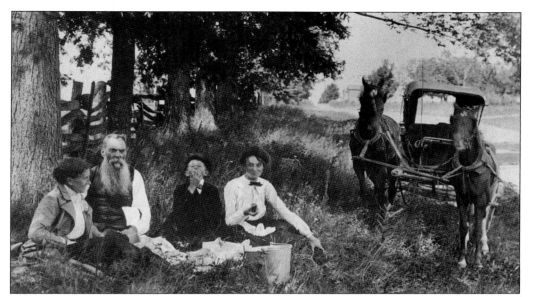

In 1846, Currier built a factory to manufacture starch that kept local farmers busy harvesting potatoes, and he sold it in 1852. From left to right are Sarah Ovens, Lewis Fitch, Frederick Currier III, and Mayne Currier having a picnic. The photographer was Currier Ovens; he was one year older than Frederick Currier III, who is making faces at Ovens. During World War I, Frederick was a medical officer in Paris. (Courtesy of AHS.)

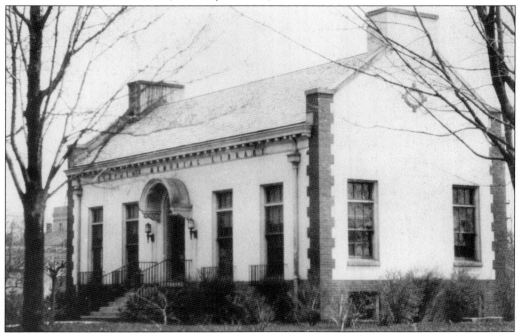

Henry Stephens, born in Dublin, Ireland, in 1823, opened a store on the east side of South Main Street in Almont in 1845. Stephens cornered the supply of iron nails in Michigan during the Civil War and made millions selling lumber and nails. He and his son Albert donated the funds for Almont Stephens Memorial Library on West St. Clair Street. (Courtesy of AHS.)

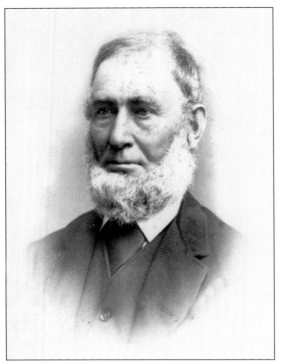

The Cooleys were New Englanders and staunch abolitionists. Before the Civil War, slaves were smuggled across the Ohio River and into Canada through the Underground Railroad. Dyke's home at 5191 Casey Road was a part of this highly organized activity, and he carried the only key to the hidden room where he would hide escapees. Dryden residents nicknamed Dyke "Grandfather Cooley." (Courtesy of DHS.)

Noah Cooley (1801–1877) was Dyke's eldest brother. The two brothers were inseparable in their beliefs. Bounty hunters were tough and ruthless men who hunted down runaway slaves for the reward money. Anyone who got in their way could end up dead. During nights that slaves were moved, Dyke sent his family to bed, cautioned them not to light any lights, and not to come downstairs if they should hear any noises. (Courtesy of DHS.)

Anna Anderson Cooley was Noah Cooley's wife (1804–1880). She knew of the secret hiding place in the cellar on Casey Road owned by her brother-in-law. Aiding runaway slaves was against the law, which was viciously enforced. Being an abolitionist did not put someone above the law. Anyone abetting the Underground Railroad could be, and usually was, jailed. That is, if they were not killed by the bounty hunters. (Courtesy of DHS.)

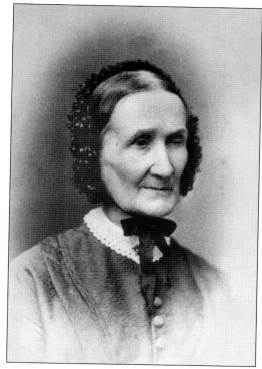

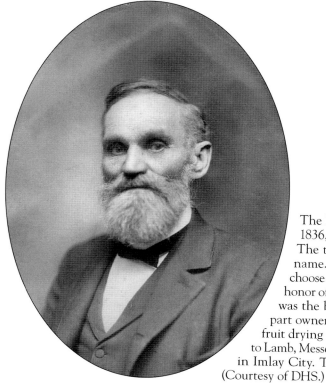

The Lamb family heritage dates back to 1836, when Dryden was named Amboy. The townspeople decided to change the name. Lamb asked Sanford Kendrick to choose the next name; he chose "Dryden" in honor of the poet Dryden. The Lamb family was the bedrock of the village. Lambs were part owners in many establishments from the fruit drying plant and grain elevator in Dryden to Lamb, Messer & Co. General Merchandise Store in Imlay City. There was even a Lamb's Corners. (Courtesy of DHS.)

Edward Lamb comes from a long line of Lambs who settled in Dryden and built one of the largest stores in Imlay City. The Lambs operated the store for 36 years. Dry goods, hardware, shoes, and groceries were found beneath one large roof. Edward built a beautiful Victorian colonial home that stands on Main Street. (Courtesy of DHS.)

Emma Foot was born in Dryden on April 4, 1849, and died on December 28, 1912. She never married. As told in *Pioneer Families and History of Lapeer County*, her pallbearers were her six nephews: Rev. William Kendrick of Traverse City, F.W. Kendrick of Pontiac, Winfield Scott Kendrick of Flint, Carson Foot of Albion, and Morris and Harold Foot of Dryden. (Courtesy of DHS.)

George Owen Squier was born in 1865, and his sister Mary was born in 1867. They were orphaned and left penniless at an early age and placed into different homes. George made the best of each brief reunion and encouraged Mary to study hard and become the teacher she aspired to be. George studied assiduously and graduated from Dryden High School in 1882. His road to fame began in 1883 when he won a competitive examination and was appointed a cadet at the United States Military Academy in West Point, New York. (Courtesy of DHS.)

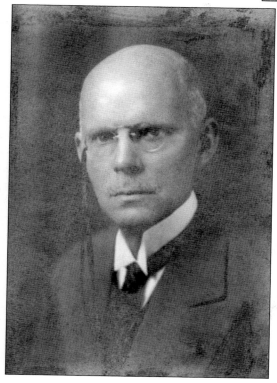

Squier enjoyed inventing for the pleasure of improving life for others. As written in *The Country Gentlemen*, Squier said after a trip to Europe: "Those people, from the highest to the lowest, get something from life on the land that is fine, Americans miss it. We have been working too hard to look around us and think of beauty." That idea sparked Forest Hall, also known as the "Country Club for Country People" and appropriately nicknamed the "Golden Rule Club." Operating to this day, the park includes a water park and is located on Mill Street and Casey Road. (Courtesy of DHS.)

Mary Squier Parker (1867–1942) was eager to please her brother, whom she fondly nicknamed "The General." She was quoted in *The Country Gentlemen* in June 1930 saying, "I used to lie awake nights worrying, wondering how in the world I could ever accomplish what he (the General) had his heart so set on. It would have killed me to fail. And I guess God helped me not to." (Courtesy of DHS.)

This is a photograph of Ira E. Parker as a boy. He married Mary Squier on January 6, 1882. They had four children, one of whom died in childhood, and they adopted a little girl. Dr. Parker may have entered his profession because of his mother, Marguerite Parker, who was very ill for part of her lifetime (1899–1906). He wrote "Mother Dear" on her picture. Marguerite is buried in Dryden Cemetery, and Dr. Parker died February 20, 1935. (Courtesy of DHS.)

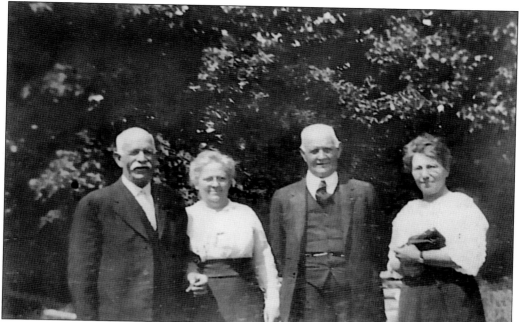

From left to right are Homer Parker, Mrs. Homer Parker, Dr. Ira Parker, and Mrs. Mary Squier Parker. Homer Lafayette Parker owned the drug store in Dryden. The family was made up of well-educated businessmen and soon Parker Block became a well-known landmark. (Courtesy of DHS.)

The first postmaster in Dryden was Joe Manwaring. He acquired his appointment from President Lincoln, and in 1885 was elected as a representative for Lansing, Michigan. As told in *History of Dryden*, he acquired the name "Father of Dryden" through the years by the residents of Dryden. The Honorable Joseph Manwaring died in his Dryden home on February 6, 1905, of paralysis. (Courtesy of DHS.)

Ella Snover was fondly called "Aunt Ella" by everyone in Dryden. Snover started her career as a school teacher before she was married. She also became one of the first female registered pharmacists after marrying Joseph Manwaring, and was a charter member of the Ladies Library Association. After being widowed, she joined the volunteers for the Salvation Army in Detroit. (Courtesy of DHS.)

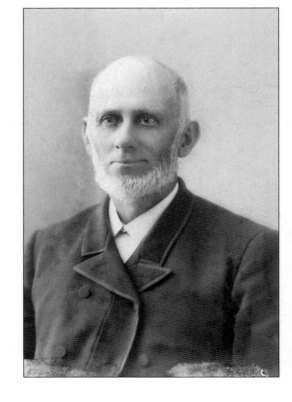

Joseph Darwood, Esq., came from New Jersey and was the proprietor of the apple drying business in Dryden. A master builder a portion of the time, Darwood dealt in livestock and became an extensive lumber dealer. He built churches in Whigville, Metamora, and Attica, as well as three union schools and many private residences, including the Darwood house. (Courtesy of DHS.)

E.J. Millikin Sr. moved from the Scotch Settlement in Almont to Dryden and started the Millikin Lumber & Coal Co. in 1909. The Pontiac, Oxford, and Port Austin Railroad brought in lumber. In 1970, Penny Millikin was the fourth generation to join the family business, the oldest family-owned business in Dryden. (Courtesy of DHS.)

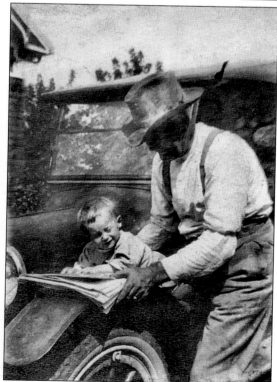

Grandfather Millikin poses with Erie J. (E.J.) Millikin Jr. on his automobile. E.J. never forgot the times he talked to down-to-earth Maj. Gen. Squier who flew with the Wright Brothers. After World War II, E.J. joined the family business and became the manager. Millikin Lumber helped Detroit Edison build the first all-electric homes in Lapeer County. The business dissolved in 2006 after 96 years of dedication to Dryden. (Courtesy of DHS.)

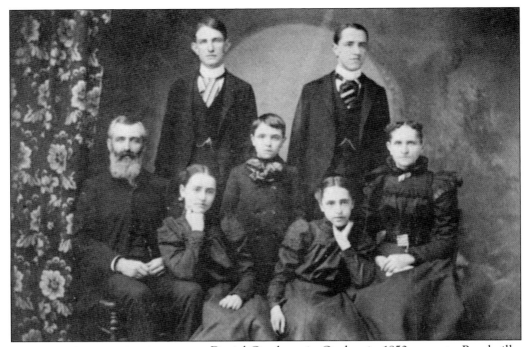

Daniel Orr, born in Quebec in 1850, came to Beechville, Michigan (later named North Branch), in 1865. He worked as a hired hand to Charles Hugill and married Martha Hugill in 1876. Daniel and Martha had five children: from left to right are (first row) Lulu and Mildred Orr; (second row) Daniel, Dwight, and Martha; (third row) Clare and Octie. Daniel died in December 1920 and Martha in September 1932. (Courtesy of NBHS.)

Warren Crawford was the first child of Samuel and Elmyra Crawford. He married the daughter of Samuel and Ann (Stroup) Whitney. As told in *History of North Branch 1855–1980*, there are five generations of Crawfords living in this area: Mrs. Martin (Ida) Crawford, Harold Crawford, Fred Crawford, Ann (Crawford) Brannan, and Gregory and Christopher Brannan. (Courtesy of Fred Crawford.)

Isaac A. Blackburn came from Canada to craft furniture in the 1800s, but people started asking him to build coffins. As told in *Sesquicentennial of North Branch 1855 to 1980*, this undertaking prompted Blackburn Funeral Home. Blackburn learned the science of anatomy and embalming and was then further called upon to help move injured people; thus, Blackburn Ambulance Service began. (Courtesy of Kelly Martin.)

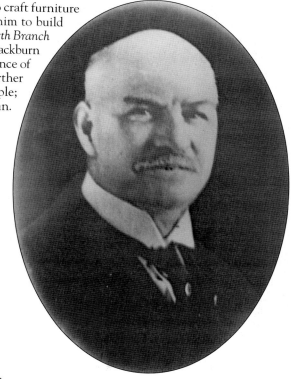

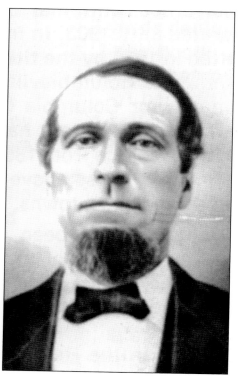

In the fall of 1847, Levi Cutting journeyed with his family to the remote part of Lapeer County that became Columbiaville. As told in *A History of the Columbiaville Area* by Robert L. Blue, the Cutting family's only child was terribly ill and Levi wrapped him in his arms and carried him on foot as he waded across the Flint River. (Courtesy of CHS.)

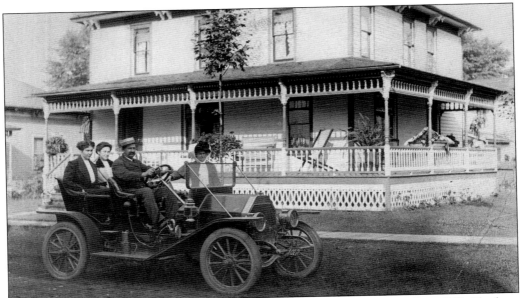

Mr. Clute, Mr. Willey, and Mr. Hollenbeck were the sole settlers in Columbiaville in 1837. Abraham Hollenbeck bought the northwest quarter of section 21 in 1836. The first religious service was held in Hollenbeck's home. Hollenbeck's neighbors often kidded him that he was the only pious man in the township. One time, his oxen fell through the ice, but his sleigh caught on a stump so he was able to escape. With the aid of Clute and Willey he rescued his oxen and sleigh. This picture is of Sumner Hollenbeck in his Buick before his residence on Pine Street. (Courtesy of CHS.)

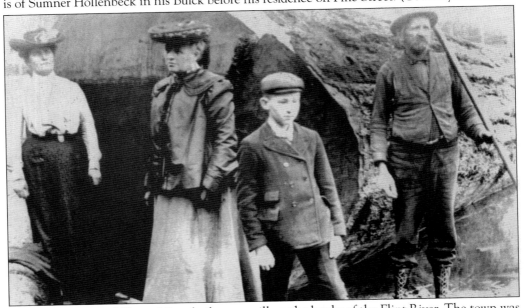

In 1848, George and Henry Niver built a sawmill on the banks of the Flint River. The town was first called Niverville, but later the name changed to Columbiaville. William Peter, born in 1824 in Hamburg, Germany, came to Columbiaville to work at Niver's sawmill in 1850. Peter, the man with the pike pole at far right, fell in love with 17-year-old Roxanna Clute. Her father disapproved, so the couple eloped in 1852. (Courtesy of CHS.)

Two

PROGRESS

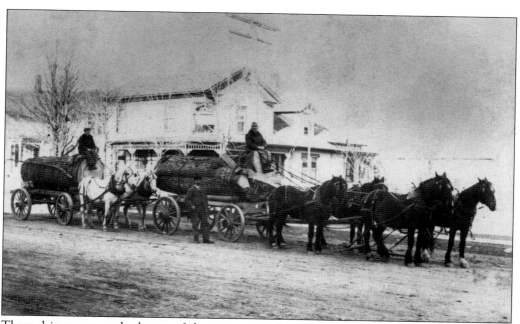

These drivers sat on the logs as if they were easy chairs. Some immigrants made a fortune in lumber. Henry Stephens was characterized as a lumber baron before his death in 1886. When the Detroit and Bay City Railroad opened tracts of land, Stephens encouraged Uriel Townsend and F.P. Currier to invest in the forests near Fish Lake. Other tracts of pine included Columbiaville. William Imlay and Walter Beech set up sawmills in Almont. Imlay City was named after Imlay, even though Imlay left to return east in the early 1840s. (Courtesy of AHS.)

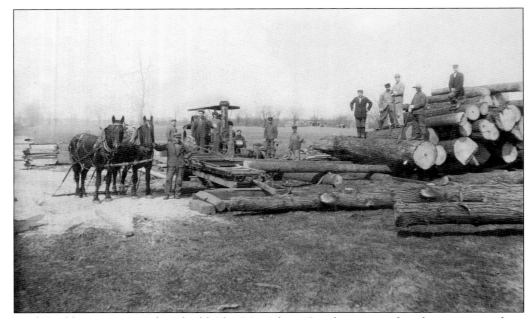

Brad Kimble is getting ready to build Alex Muir's barn. Lumber was used in things ranging from buildings to roads. Roads were almost impassable in wet weather, so plank roads, or corduroy roads, were made. These roads were as important as the railroad. Farmers hauled their produce to markets in Detroit and needed to be sure they could get there. They were paid in cash. As told in *Almont the way it was*, holdups occurred often while traveling through the woods on their way home. (Courtesy of AHS.)

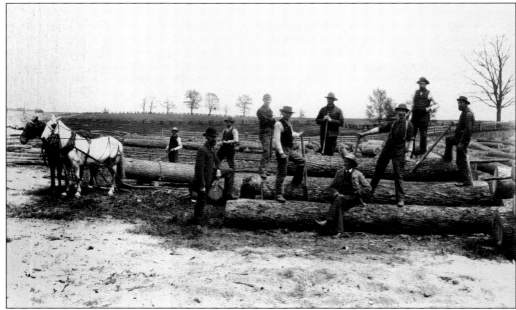

At Almont's R.K. Farmum's log yard, horsepower was the means of hauling everything from these 10-foot logs, to plowing the fields, to driving a stagecoach. For 25 years, beginning from 1844, the route from Almont to Detroit was by stagecoach on wooden plank roads. (Courtesy of AHS.)

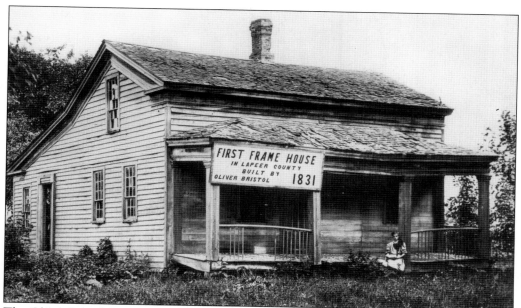

The Oliver Bristol frame house is located on the west side of Van Dyke about a quarter mile south of Hough Road. As told in *The History of Almont,* Oliver set out for meat one day only to have a near-death experience when he fired on a bear, and the beast lunged for him. He dropped powder in the pan of his flintlock as the bear rose up on its hind legs to attack him. (Courtesy of AHS.)

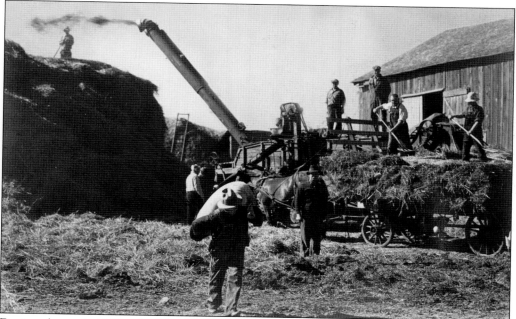

During the early 1800s, the Huron Indian named Tip-si-co acquired local fame as a cradler. He could rake and bind with the best of them. When the Indians were forced to leave their village, Tip-si-co returned from the reservation on Walpole Island to participate in Almont's first homecoming. This image shows farmers threshing wheat and straw. (Courtesy of AHS.)

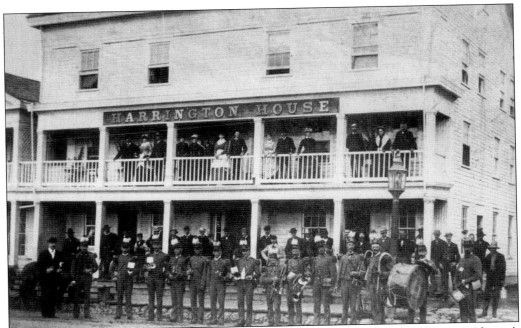

The Harrington House was built in 1829. The hotel is thought to have burned during Almont's first fire on the north part of Main Street. It is not clear if James Harrington built this hotel. Harrington built the Imlay City Hotel in 1860, but the Whitney family, who owned a circus, later purchased it. (Courtesy of AHS.)

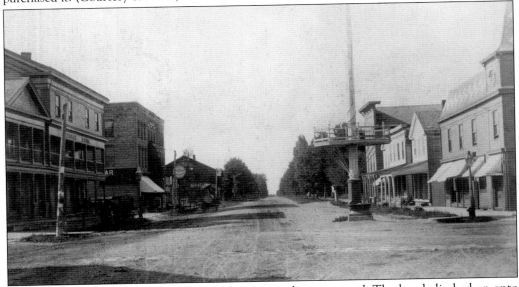

On July 4, 1865, the Liberty Pole and watering trough was erected. The band climbed up onto the circular stage and played during the first homecoming in celebration of the end of the Civil War. To the right, in front of Ferguson Bank, is a lamp. This kerosene lamp was hand lit every evening by Mr. Fisher. He would carry his ladder around and light the lamps scattered about the village at dusk. During the day, he trimmed the wicks, cleaned the lamps, and filled them with fuel. (Courtesy of Paul Bowman.)

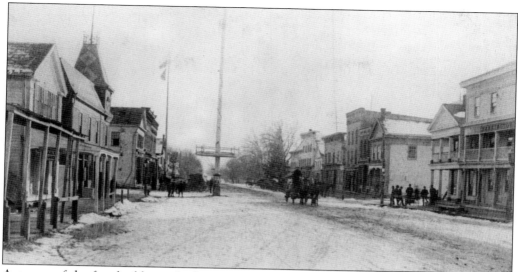

A corner of the first building, which was Simon's Hall, is visible here. There used to be roller skating on the third floor. The next building was patronized by a rough, gambling bunch of men. The third building was the tailor shop and the fourth was C.R. Ferguson's bank building. This building was also occupied by Mary Howland's Millinery. Hancock's Studio was upstairs. The Liberty Pole was made of two pine trees from Black's Corners and driven in by a six-horse team. (Courtesy of AHS.)

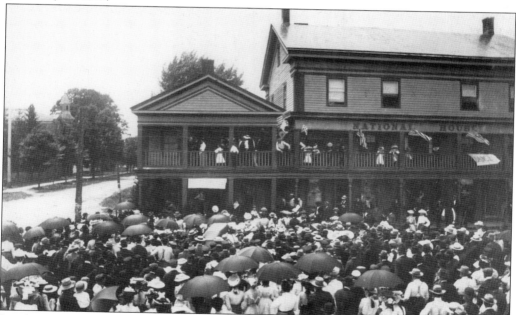

In 1866, Almont's business district rebuilt again. The National Hotel was finished, located on the corner of West St. Clair and North Main Streets. Upon the completion of the first brick schoolhouse, there was a benefit dance at the school (evidenced by the banner). People from Romeo and surrounding towns attended. Suddenly, a fire broke out in the hotel's barn, and around 23 horses were burned alive. The fire spread through the business district before it could be controlled. (Courtesy of AHS.)

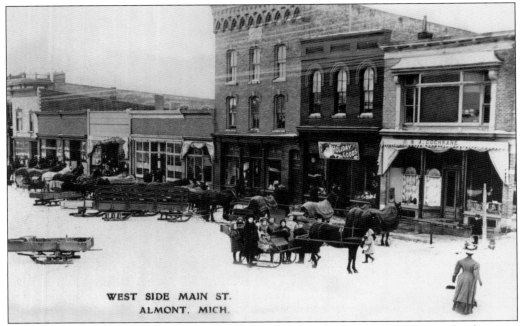

WEST SIDE MAIN ST.
ALMONT. MICH.

It is the Christmas season in Almont. A stylish lady and a sleigh full of children make their way down Main Street to D & A Cochrane's store. The Cochranes lived in the Scotch Settlement. Begun in 1833, the Scotch Settlement was the first permanent settlement in Lapeer County. (Courtesy of AHS.)

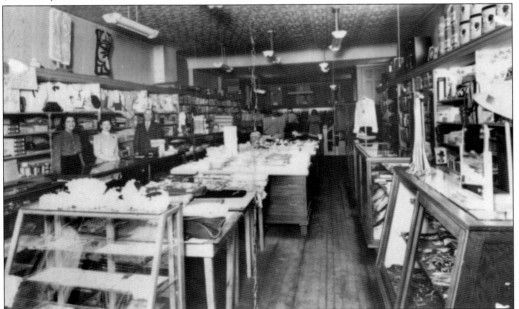

Christmas season at Cochrane's store was the most memorable time of all. As told in *Almont the way it was*, "Its two floors were stocked with dry good and groceries, china and cheese, overalls and overshoes and just about everything you could thing of." Many children enjoyed their first taste of rock candy at Cochrane's. (Courtesy of Paul Bowman.)

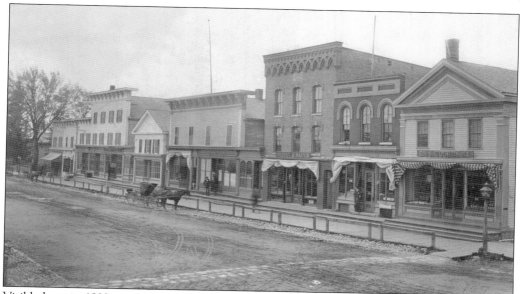

Visible here in 1892 are Cochrane's store, Bowman Drugs, Colerick & Martins, and the dental office. As told in *Almont the way it was*, Bowman Drugs, purchased in 1883, had three barrels of liquor in the basement and customers would bring their own bottles to be filled, or purchase a bottle. Bottled liquor was not normally available. Whiskey and scotch were used for medicinal purposes before Prohibition. There were wooden sidewalks and a stone crosswalk. (Courtesy of Paul Bowman.)

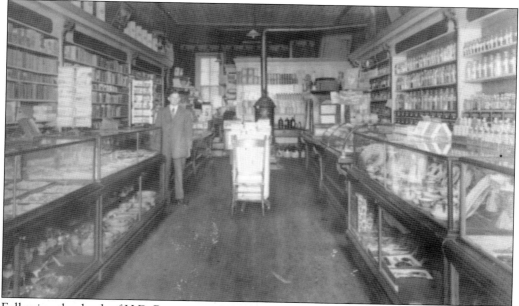

Following the death of H.D. Bowman in 1926, his son Harry became sole owner. Harry installed a soda fountain, and was nicknamed "Mr. Almont" because if anyone wanted to know Almont history, they talked to Harry. The third generation of the Bowman family, Robert, graduated from college in 1949. In 1975, Robert sold the family business to James Henderson of Henderson Pharmacy. (Courtesy of Paul Bowman.)

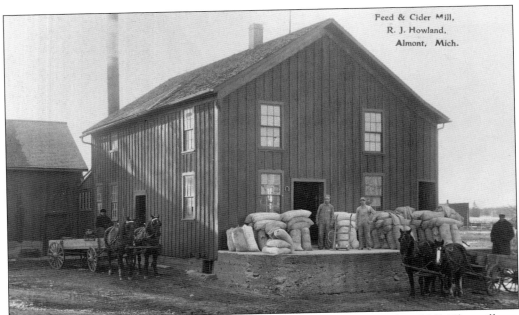

Elmer Briggs bought this mill in 1845 and turned it into the Briggs Carding Mill. The mill was powered by a water wheel. Briggs sold the mill to his son Elmer in 1885. William King bought it in 1915, and waterpower was replaced by a steam engine. W.H. King's Flour and Feed Mill's steam engine was replaced with electric motors. When larger mills outbid King, he expanded his feed services to livestock farmers, grinding tons of feed a day. (Courtesy of Paul Bowman.)

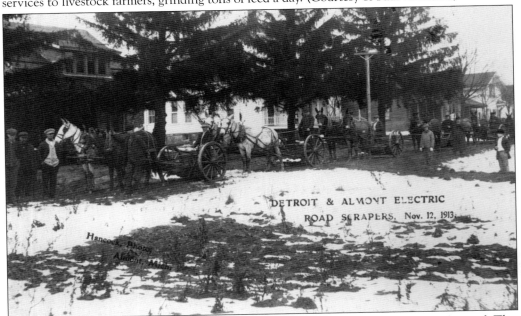

Progress was stepping forward in giant leaps, indicated by the electric poles lining the road. This brought more jobs and the need for road scrapers to insure the roads were passable for the new motor cars. These horses wait patiently to tend to the needs of this new type of horsepower that would eventually take over their jobs. (Courtesy of AHS.)

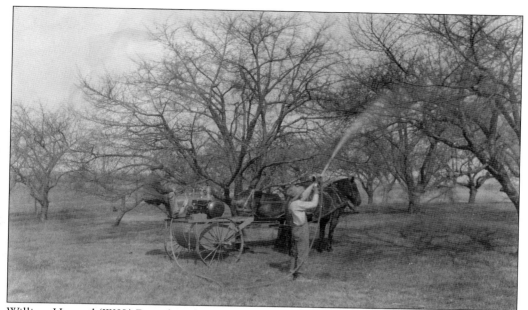

William Howard (W.K.) Bristol graduated in 1880 from Michigan State University and then went to University of Michigan to become a teacher and later a lawyer. He came back to the family farm and started a legacy for future generations, Brookwood Fruit Farm. The first orchards were planted along Kidder Road in 1912. Here W.K. Bristol is spraying his fruit trees. (Courtesy of William Bristol.)

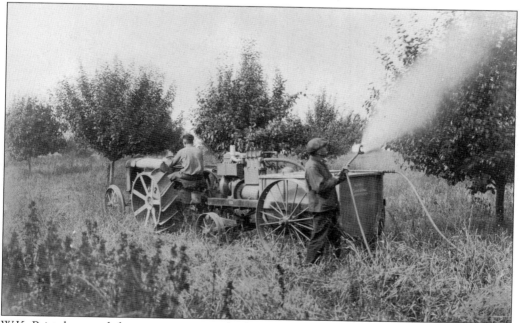

W.K. Bristol sprayed the trees as soon as the leaves were the size of a squirrel's ear, even in the rain. The fungus that grew like moss due to Michigan's wet climate made spraying a necessity. In order to have large apples, the clusters of blossoms would be hand pruned so the king bloom, the strongest one, would grow a hearty apple. (Courtesy of William Bristol.)

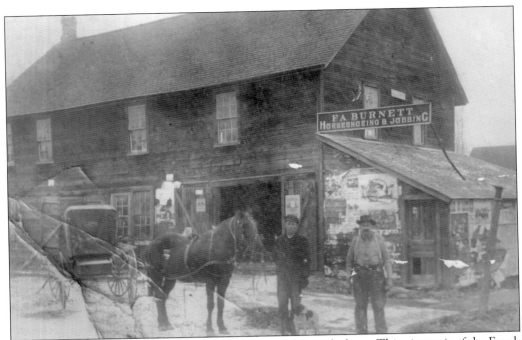

At the turn of the 20th century, Dryden had three blacksmith shops. This picture is of the Frank Burnett blacksmith shop. The Burnetts came from New York, and their first blacksmith shop was built in back of their house. For years, Burnett's blacksmith shop also served as a tailor. Burnett's great-grandfather Brazilla Davis came from New Jersey to live with them and was a fine tailor. This picture is labeled: "Dad and me taken 1907 dog is Fanny." (Courtesy of DHS.)

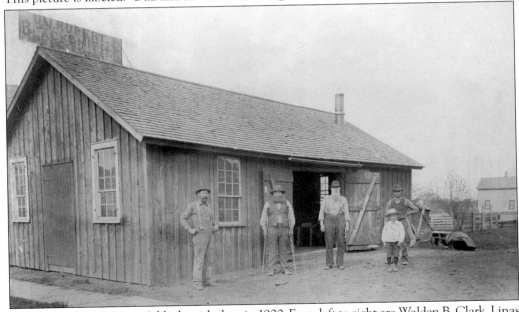

Seen here is Joseph Rupert's blacksmith shop in 1900. From left to right are Walden B. Clark, Linas Fisher, Joseph Rupert, and Ira Banister. The young boy is unidentified. This shop was located on the east side of Mill Street, south of Ralph Hebert's Home. (Courtesy of DHS.)

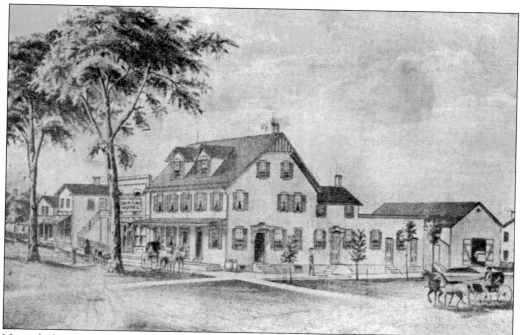

Named after the twin elm trees that towered in front, Dryden's Twin Elms Hotel was built in 1874 by Joseph Darwood. It was a popular hostelry in the county and used by the traveling public in the stagecoach and horse-and-buggy days. (Courtesy of DHS.)

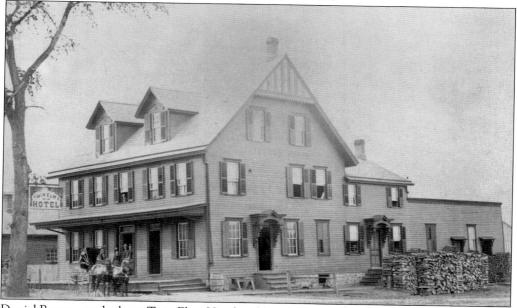

Daniel Bacon ran the large Twin Elms Hotel and later bought it. Bacon was a pioneer of Almont and Dryden and a son-in-law of John M. Lamb. In 1917 the building was sold to Fred Blow, who remodeled it into a hardware store in the 1920s. It later became an IGA. When the IGA closed, the building stood empty. The floors rotted and the building was demolished in 2003. (Courtesy of DHS.)

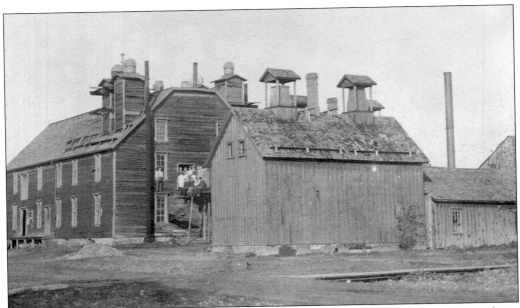

The Dryden Apple Drying Establishment was located in the south part of the village and was established in 1876. It burned down in 1881 but was rebuilt. Thousands of barrels of apple cider have been made here. Around 25 tons of fruit were dried a year. (Courtesy of Peter Ulrich, DHS.)

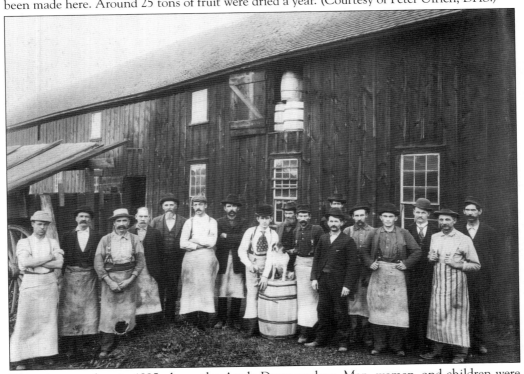

This picture, taken in 1895, shows the Apple Dryer workers. Men, women, and children were employed during the fall to dry the fruit. The work of drying the fruit ran for two months, 24 hours a day on a weekday, and the workers did 80 to 100 bushels of apples a season. (Courtesy of DHS.)

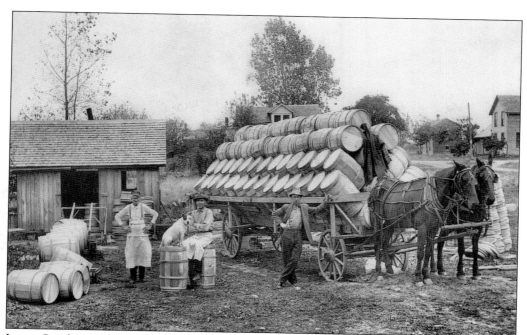

James Quigley's Cooper Shop provided the Dryden Apple Drying Establishment barrels for its apple cider. James and Mary Quigley lived on Mill Street, north of North Street. The village was surrounded by orchards and all thrived at the turn of the century. (Courtesy of DHS.)

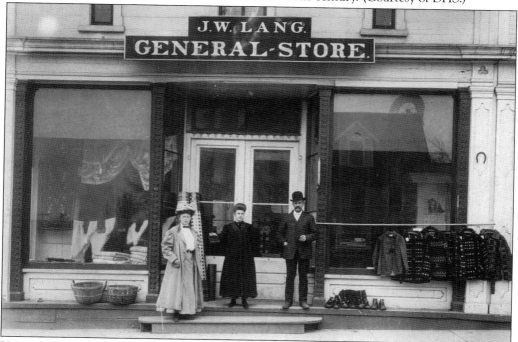

Here is the J.W. Lang General Store, owned by John Lang. From left to right are Besse Hatherly, Nette Slate, and John Lang. This store stood on the southwest corner of Main Street. (Courtesy of DHS.)

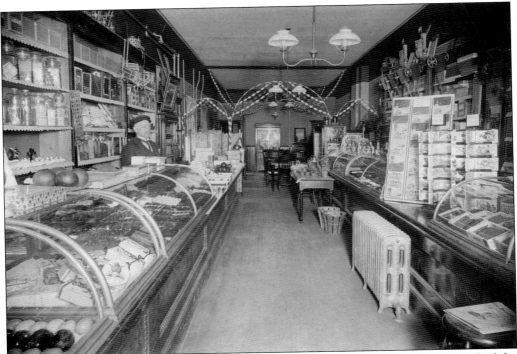

Caleb Tibbs stands behind the counter of Dryden's General Store. This store is typical of the early 1900s. On one side of the narrow store are all types of pastries, breads, and hard candies. On the other side are cigars, newspaper, toys, and baskets. Toward the back sit tables and chairs for the shoppers to take time to enjoy their pastry or cigar. (Courtesy of DHS.)

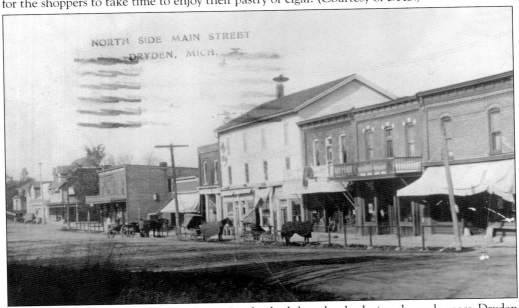

Looking at the north side of Main Street, Dryden had three banks during the early years: Dryden State Bank, started in 1901 and closed in 1932; John Lamb and Mart Heenan Bank; and Berridge and Slate Farmers Exchange Bank, which dissolved around 1913. (Courtesy of DHS.)

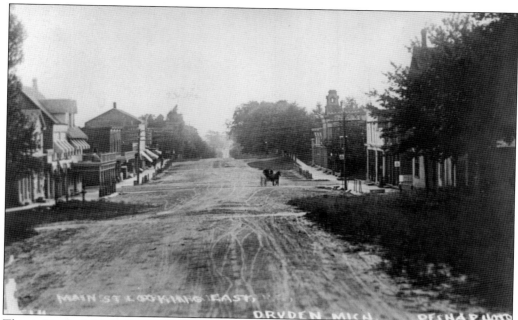

This is Dryden's Main Street looking east. A wagon makes its way down the road. The electric lines running across Main Street show that the picture was taken after 1915. It could have been March 1919, when Dryden was hit by the worldwide flu epidemic. As told in *Pioneer Families and History of Lapeer County*, "All business places were closed, with orders were taken by phone and handed to customers at the door." (Courtesy of DHS.)

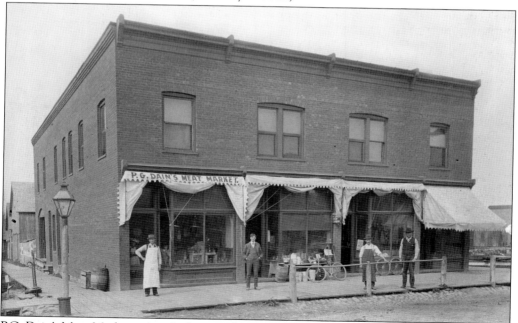

P.G. Dain's Meat Market enjoyed a busy trade in 1901. This butcher shop was located just east of the bank. Sadly, Dain's butcher shop burned down in 1934. The story goes that the fire started in their building while rendering fat to make lard over an open fire. (Courtesy of DHS.)

In 1898, the Dryden post office was the main mode of communication between the community and the rest of the country. Postmaster Tom Williams is sitting in the wheelchair and Elmer Mayhard, mail carrier, is standing on the steps. Getting mail delivered was not easy in the 1800s. Fighting snow drifts and washed-out roads, the mail carrier often brought more than mail. He alerted rural residents of news from the outside world. (Courtesy of DHS.)

During 1881, P.M. Ulrich owned this store. He later sold it to John Heenan, who then sold it to Charlie Walker. Walker used it for a general shoe store. The Parker brothers had a drugstore next to Walker's store. A fire burned Wilson's, Walker's, and Parker's down and left one store, owned by Clarence Allen. (Courtesy of DHS.)

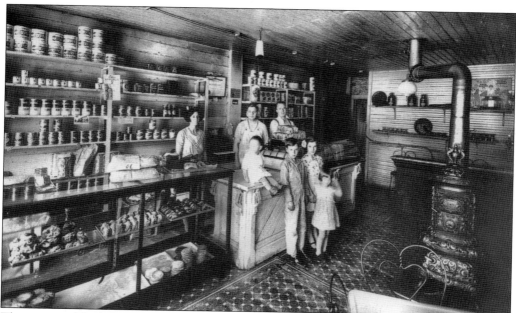

The aroma of fresh bread and pastries flavored the street outside. The Dryden Bakery was a popular place to catch up on gossip as well as to satisfy a sweet tooth. From left to right behind the counter are Emma and Fred Stayhue and Richard Coon. Fred Stayhue Jr. sits on the counter. In front are Dean Wilson and Harriet and Vivian Stayhue. (Courtesy of DHS.)

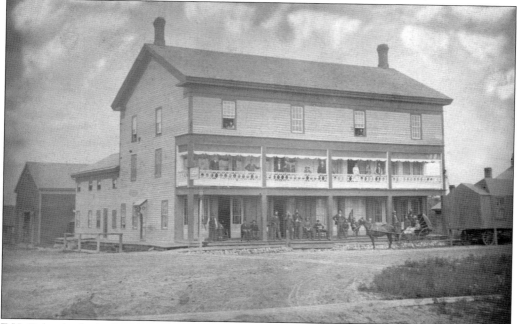

E.H. Baker built the Dryden Exchange Hotel in 1854. The hotel stood on the northeast corner of Main Street. It changed ownership during the late 1800s and became the Dryden Eaton Hotel but burned down in 1889. Sam Utley erected a brick building. The east half of the building was used for two banks. (Courtesy of Peter Ulrich, DHS.)

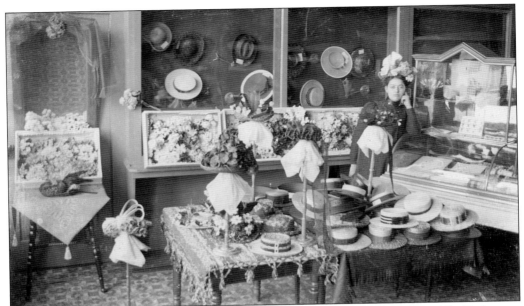

Allie Parker's Hat Shop provided an important part of a lady's attire in the 1800s. Allie Parker was the wife of Homer Parker, Dryden's pharmacist. Her hat shop was a small brick building that sat on the west side of the library. Both buildings were torn down in the 1980s. (Courtesy of DHS.)

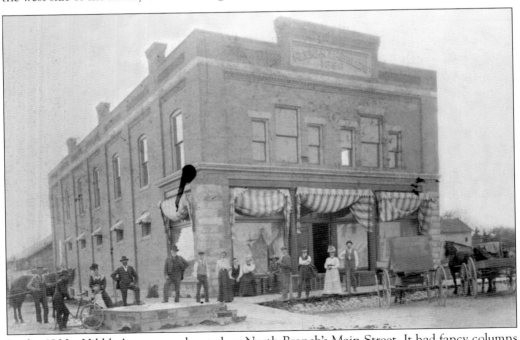

In the 1800s, Hibbler's store was located on North Branch's Main Street. It had fancy columns inside and Hibbler sold just about anything that was not grown on the farm as well as items that were. Hibbler had everything from bolts of cloth to barrels of flour, from farm-fresh eggs to hand-churned butter. Saturday shopping excursions were a time to get dressed up and catch up on the latest news. (Courtesy of NBHS.)

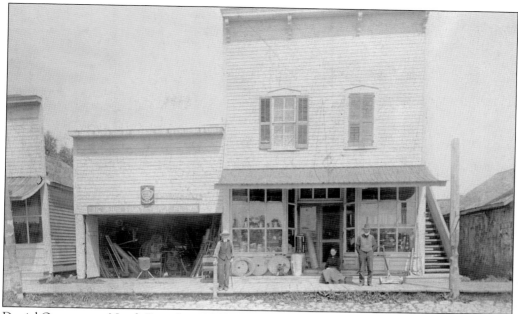

Daniel Orr came to North Branch in 1865. He first had a meat market, and then worked as a log drover. He opened his hardware store in 1875. Here Daniel stands and Martha Orr sits out front. Three years later, fire destroyed Daniel's lumber and hardware businesses. The Doc Best office is on the left, and on the right is the Baldwin Shop. (Courtesy of NBHS.)

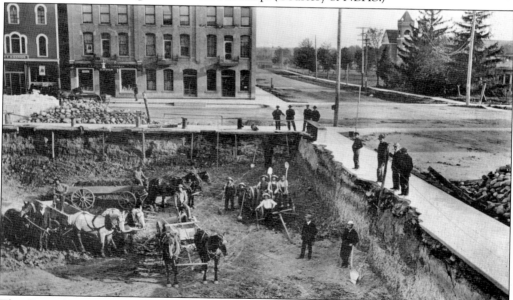

The Orrs of North Branch dug this basement one shovelful at a time in the winter of 1906. Pictured in the spring of 1907, the men in the basement are, from left to right: O. Orr holding pony, Robert Rutherford with grey team, George Rutedge with the team at back, John Newcomb with a team at right in front, an unidentified lone man, and M.R. Dee at the plow. On the cement sidewalk from left to right are unidentified, Daniel Orr, and Freeman Ward. Rocks were used for the walls of the basement. (Courtesy of NBHS.)

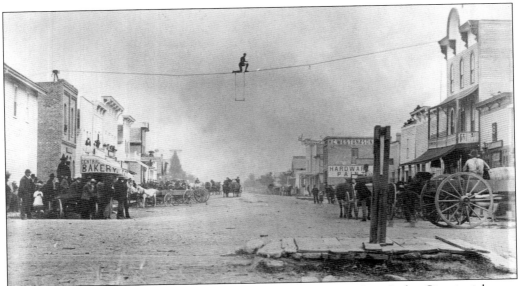

A man, probably one of the Whitney Family Circus performers from Imlay City, is tightrope walking across Main Street. Whitney shows operated from 1879 to 1908. The performers lived at Imlay Hotel in 1860 on Blacks Corners. The pump in the foreground stood in the middle of North Branch's four corners, made up of Jefferson and Huron Streets. The Methodist Church is not seen here. The church was built in 1902, so this picture dates before that. (Courtesy of NBHS.)

George L. Whitney (1833–1889) began the Whitney Family Circus with a minstrel show. Acrobats, trapeze, and rope-walking acts followed. Animals and a sideshow were added later. By 1882, the show included 32 wagons and 64 horses. Whitney bought the Imlay Hotel mainly for its large barns for the circus's winter quarters. In 1884, Whitney combined with Locke and Long's Acrobatic Troupe. From 1899 to 1903, it was called Whitney's Big One-Ring Circus. (Courtesy of *Detroit Sunday News*, February 1920.)

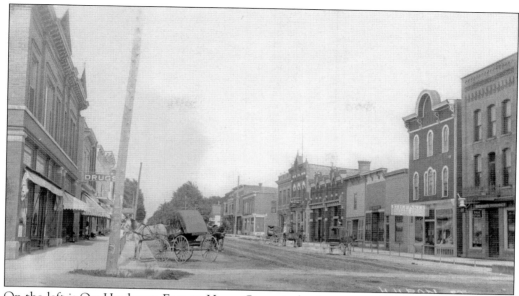

On the left is Orr Hardware. East on Huron Street is the drug store of William Murch and the Old Brown Store. The third story was the Masonic hall. The second story was a residence and the first floor was a store. East of that is a barbershop run by Henry Pratt, followed by Alex Webb and later, by Dr. Snow. The next building is Pioneer Bank, founded in 1885. Mahogany and wrought iron teller windows complement the interior of this remodeled 1906 classical structure. The bank still services the community today, operating as Independent Bank. (Courtesy of NBHS.)

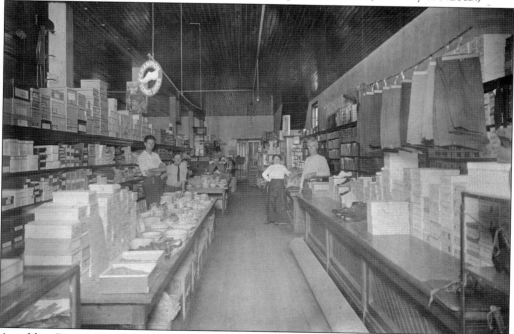

As told in *Pioneer Families and History of Lapeer County*, it was about 1880 that Harry and Grace Ford began an apparel and dry goods store. This store was passed to their son, Harry Jr. It was operated for many years by Raymond Ball. (Courtesy of NBHS.)

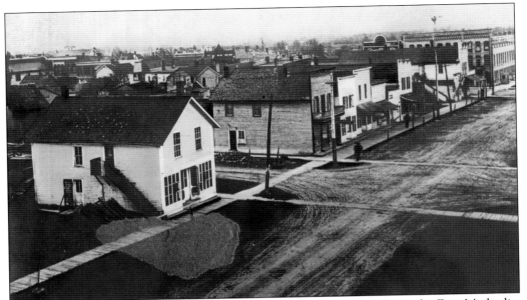

Looking from the belfry of North Branch's M.R. Church, which was once the First Methodist Church, the first building on the left is the old tailor shop of Mr. Reynolds, now known as the Ross Hallock Home. The second building is the H & G Ford Store, followed by a dentist's office. The fourth and fifth stores are the Kate Gage Millinery Shop and Dr. Bert's. The sixth and seventh buildings are the Orr store. The eighth and ninth buildings are the post office and Harrington Hardware, which was once a meat market. (Courtesy of NBHS.)

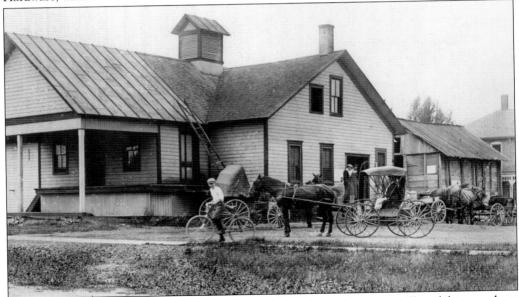

The North Branch Creamery was located on Mill Street. In rural America, milk and dairy products were made on farms. Then, with the movement of the population from farms to cities in the early 1900s, it became necessary to produce cheese and butter for the hotels and townspeople. It was during the late 1800s that cattle breeds were developed specifically for dairy purposes. (Courtesy of NBHS.)

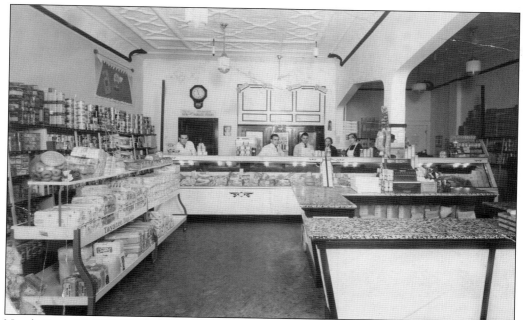

North Branch's Walt Taylor's General Store sold some choice meats. It also provided Tastee Breads and something for people's sweet tooth as well. It is believed this was on the first floor of the Masonic temple. (Courtesy of NBHS.)

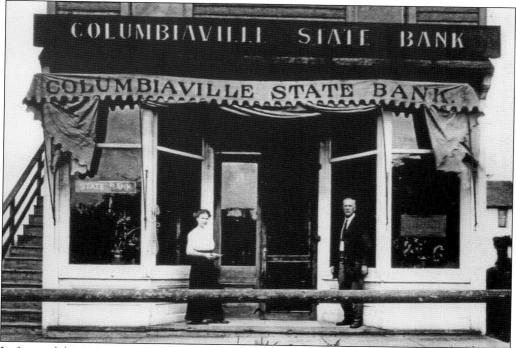

In front of the Columbiaville Bank stand Miss Bohnsack and David Butler. There is a hitching post in front, and the stairs outside lead to the second floor. This was typical of construction in the 1800s. (Courtesy of Dorothy Margrif, CHS.)

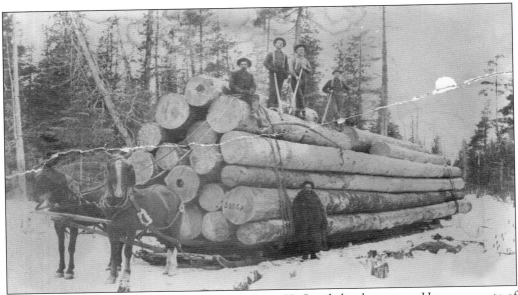

This picture was taken March 13, 1884, at the L.H. Smith lumber camp. Huge amounts of lumber were needed for building and Columbiaville's woods had a bountiful crop for the eager businessman. These men have the logs bound and tied on a sleigh. The large mound dwarfs the two horses. (Courtesy of CHS.)

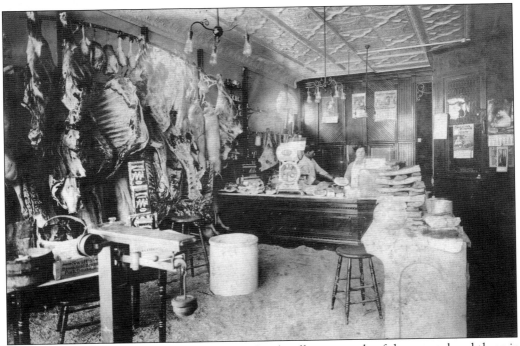

The people here are unidentified. The tin roof and walls were made of sheet metal and there is sawdust on the floor of what looks like Columbiaville's meat house. Sheet metal radiated heat or cold. This aided in keeping the meat a certain temperature without the aid of refrigeration. (Courtesy of CHS.)

Columbiaville barber Alf Burgess poses before his barbershop on Pine Street with his trusty dog. There is a candy stripe pole in front. In the early 1900s, that always indicated to the folks needing a shave or a trim where the barbershop was. (Courtesy of CHS.)

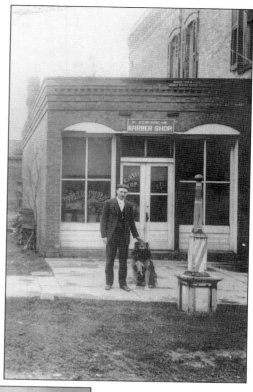

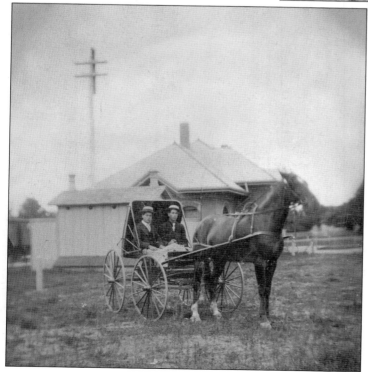

In 1879, the railroad from Detroit to Bay City steamed into Columbiaville. The first depot was a wooden structure located on the east side of the tracks at Pine Street. This depot side view shows the privy. Although there is electricity, there is still no indoor plumbing. This image was taken from a tintype. (Courtesy of CHS.)

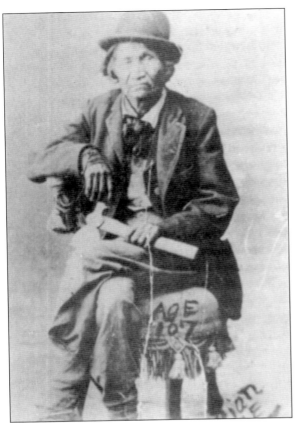

Chippewa Indian Dave was present at the signing of the 1819 Treaty of Saginaw. As told in *A History of the Columbiaville Area*, an Indian village was located at the south end of Hemingway Lake near Howell Road. The Indians would place their wigwams near their food supply, the sugar maple. They lived off that sugar during the winter. Dave had his photograph taken at William Liesaw's studio when he was 107 years old. He died that year on May 26, 1909. (Courtesy of CHS.)

Here is Skinnie Osborn in 1929. He owned the Columbiaville Osborn station at the end of Lapeer and Water Streets. He was an automobile dealer and sold Lincoln and Ford tractors. The woman at right is thought to be his wife. (Courtesy of CHS.)

Three

PERSEVERANCE

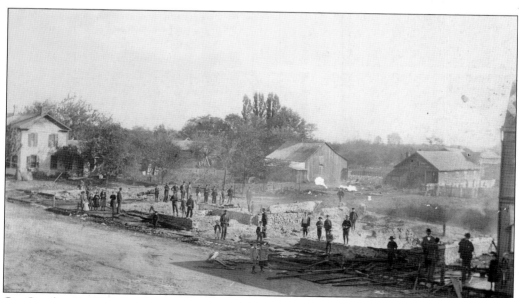

On October 5, 1894, buildings on the east side of North Main Street were burned to ashes. These included Simon's Hall and Work Shop, the *Herald* office, Taylor and Taylor, E.R. Gould, and the Harris Building. That winter, fire destroyed the buildings on the west side of South Main Street owned by John Murdock, Mrs. L.J. Eckler, J.S. Johnson, J.M. Teller, Dr. Burley, F.P. Currier, T.C. Taylor, I.T. Beach, H. Whitehead, and Dr. Bancroft. As told in *History of Almont*, all stores were wiped out except John Sullivan, H.D. Bowman, and D & A Cochrane. (Courtesy of Paul Bowman.)

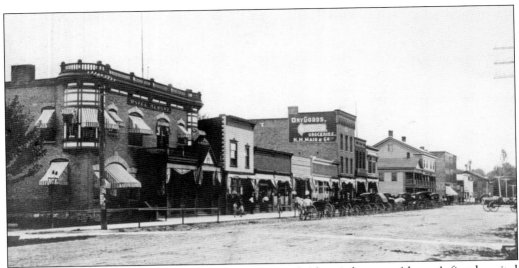

Main Street was rebuilt after the 1894 fire. The Hotel Almont became Almont's first hospital and would later become Muir Funeral Home. Donald Bowman would laughingly say that he was born in that building and that is where he would be buried. The dry goods, grocery store, and the Masonic temple building are also pictured here. (Courtesy of Paul Bowman.)

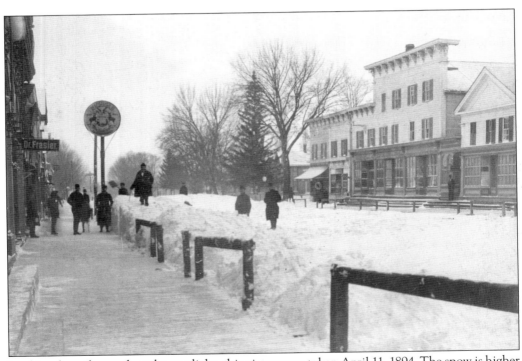

Looking from the south at the stoplight, this picture was taken April 11, 1894. The snow is higher than the hitching posts in some spots. As told in *Another Almont History*, April's heavy snows often made food scarce. The Sanborn family used straw from the family beds to keep the animals alive during the spring of 1834. (Courtesy of Paul Bowman.)

It is 1914 and young Sheldon and Leon Yoder lift hammers that appear heavier than they are, determined to drive in the first spikes for the Detroit Inter-urban Railway. This picture was taken on the border between Macomb and Lapeer Counties. (Courtesy of Phillis Bristol.)

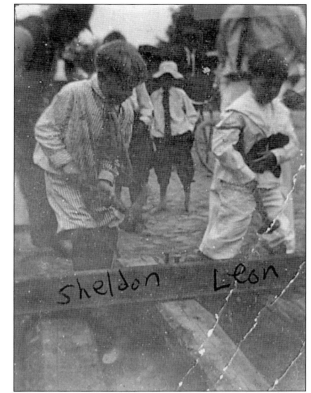

Mr. Kennett and William Merriam owned and operated the Almont Roller Mill. They made flour until the death of Mr. Kennett. It then was known as Merriam's Roller Mill and a gasoline engine generated the power with direct current for lights in the business section of town. The mill was torn down in 1939. (Courtesy of AHS.)

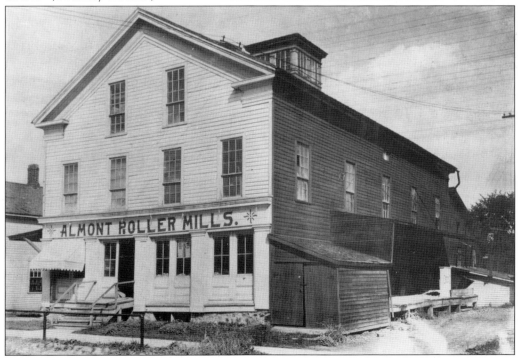

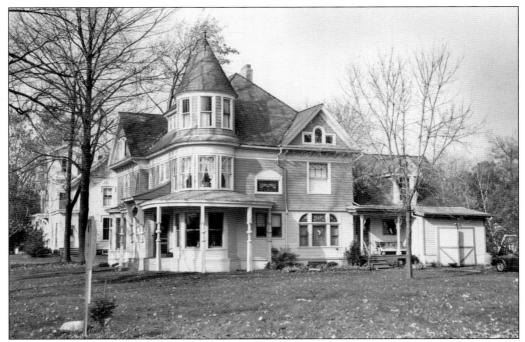

The first bank was established in 1866 by Williams and Moss. In 1895, a prominent banker named Charles Ferguson Sr. built this Queen Anne home. The home is typical of the times with its variety of shapes and textures and still stands today at 306 West St. Clair Street, restored to its original splendor. (Courtesy of David Hurd, AHS.)

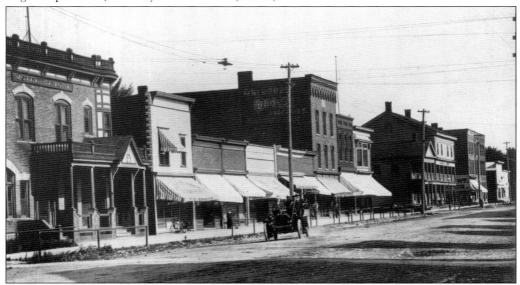

On this hot summer day, stores have spread out their canvas awnings for pedestrians. There are hitching posts and the Model T is making its way down Main Street in front of the Muir Bros Funeral Home at 138 South Main Street. As progress mapped a jagged course into America's history, the blacksmith shops faded away and were replaced with gasoline stations. (Courtesy of AHS.)

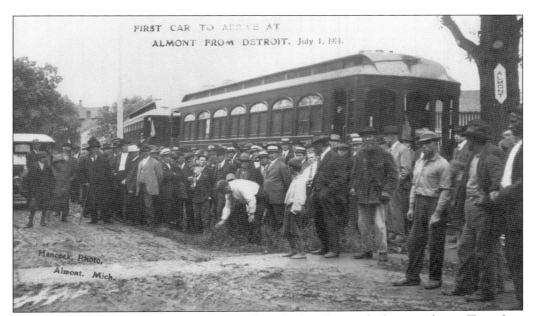

FIRST CAR TO ARRIVE AT
ALMONT FROM DETROIT. July 1, 1914.

Hancock, Photo.
Almont, Mich.

On July 1, 1914, the Detroit, Almont & Northern Railroad opened a line to Almont Township. Almont was the first town in Lapeer County to have an electric road and this brought electricity. Councilmen from Royal Oak, Rochester, Washington, and Romeo were there for its grand opening. The streetcar tracks were later extended to Imlay City. In order to do this, an underpass was built for Thomas C. Taylor's cattle. The underpass also came behind the James P. Smith home at 5320 South Van Dyke Road. The streetcar serviced the community until 1925. (Courtesy of AHS.)

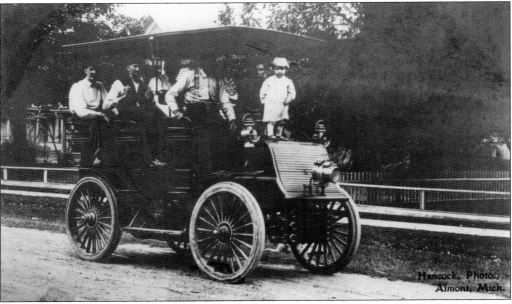

Hancock, Photo.,
Almont, Mich.

Not everyone could afford a new automobile, but there was the Pere Marquette Railroad and the Almont Romeo Auto Bus that commuted between Romeo and Almont. Robert E. Lee, the owner, is seen here behind the steering wheel. His son is standing on the hood. Lee was a descendent of the family behind Lee Manufacturing, located in the Hurd Lock building. (Courtesy of AHS.)

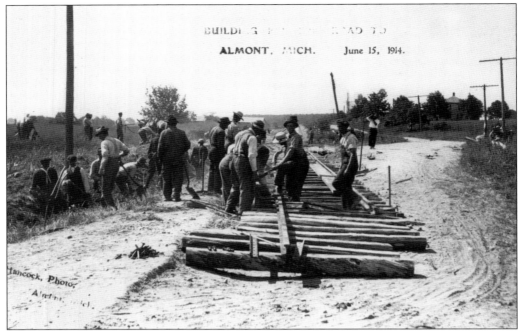

Almont's lumber was put to good use when the railroad came through. Here, a crew of men set the rails in place on June 15, 1914, for the Detroit Urban Railroad (Northern Railroad). This train would travel from Detroit to Almont. The men laid the tracks along West St. Clair, near the old town hall. In the background, the depot's old location is just visible. (Courtesy of AHS.)

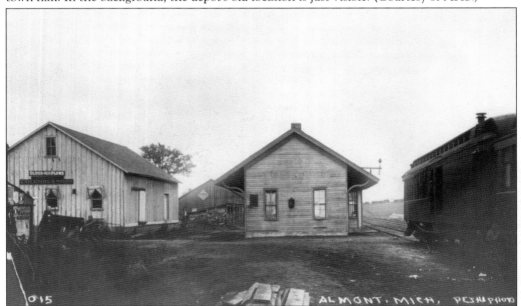

As told in *Pioneer Families and History of Lapeer County*, Almont's first railroad came in 1882 but was discontinued and sold to Pere Marquette in 1889. With this new rail line came a need to employ a crew of men. The Port Huron and South Western Railroad Company tracks were constructed between Almont and Port Huron. (Courtesy of AHS.)

This photograph was taken where Country Corner is located today. In 1889, the Flint and Pere Marquette Railroad converted these tracks to standard gauge. Stockyards were located on the east side of the highway and the animals were shipped to Buffalo, New York. In later years, lumber and coal was brought in, and beans and hay were shipped out from Almont. This branch of the railroad was abandoned in 1942. (Courtesy of Paul Bowman.)

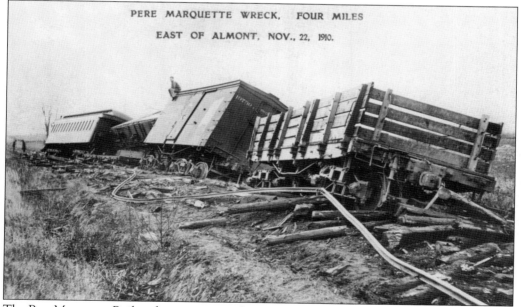

The Pere Marquette Railroad train running from Port Huron to Imlay City did not make it to its destination. The wreck happened just four miles east of Almont on November 22, 1910. The man sitting forlornly on top of one of the cars is unidentified. (Courtesy of Paul Bowman.)

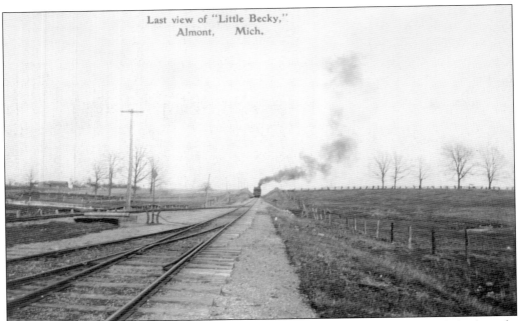

Last view of "Little Becky," Almont, Mich.

As the first electric car brought the ease of electricity to Almont, the first railroad also brought progress and a leap into the 20th century. The railroad placed Imlay City on the map and opened the "Gateway to the Thumb" to future pioneers. Sadly, what begins as progress oftentimes ends in black smoke as innovation continuously marches forward. The last train to service Almont was "Little Becky," and in January 25, 1942, she left in a puff of smoke. (Courtesy of Paul Bowman.)

Hurd Lock & Manufacturing Co. was located in the old Foundry building on the corner of North Main and School Streets in Almont in 1931. Their manufactured products included automotive locks and moldings. At the start of World War II, they produced ammunition components. In 1944, they were awarded the "Navy E" for excellence in producing war materials. (Courtesy of Paul Bowman.)

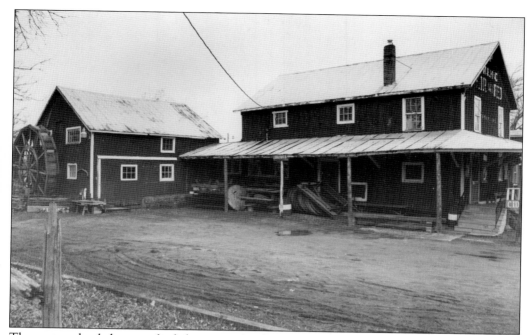

The water wheel that supplied the power for this mill stands idle now. Located at 622 South Main Street, the mill is the oldest utility building in Almont. Debra and Art Schumacher, who remodeled it, presently own it. This lovely historical site serves as The Mill and Brew House, an antique shop that can be rented for parties, weddings, and showers. (Courtesy of AHS.)

In the 1800s, Almont Elevator started as a sheep wool shop, and then was a sawmill powered by steam. In the upper story there was a sorting room where the ladies cleaned and sorted beans with a foot-powered machine. Frank Bishop purchased the elevator in 1911. In 1954, Russell Lovell bought it and it became Country Corners. Lovell sold it to Jerry and Carol Deppong and Roger and Mary Ellen Smith in 1973. Dean Barry and Jeff Deppong then bought it. The elevator provided livestock staples. Country Corner serviced the community with groceries and farm-fresh produce. (Courtesy of AHS.)

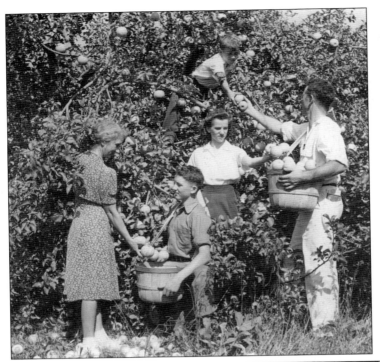

It is 1942 and harvest time for Brookwood Farms. Mom, Anne; son, William; daughter, Margaret; and father, W.K. are standing below. Robert is sitting in the tree, handing down the fruit from their year-long labors. The Bristols grew 46 varieties of apples. Five generations of Bristols went to Michigan State, with most studying horticulture, which paid off. (Courtesy of William Bristol.)

Three sisters worked on the assembly line at the apple packing plant. Dorothy, Elizabeth (Lizzy), and Ethel Marole, the oldest, work side by side with Margaret Bristol getting the apples ready for market in August 1938 utilizing this conveyor. Do not forget the hard labor of the bumblebee that pollinates the blossoms. There are at least 12 colonies in the middle of each orchard. (Courtesy of William Bristol.)

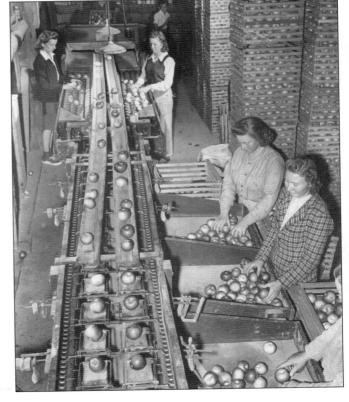

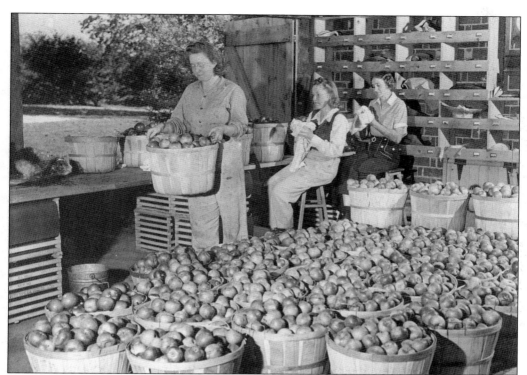

Ten bushels of these apples will go to Detroit's Tiger Stadium for Friday night's game. Before they leave, they are hand polished. Elizabeth Marole and a couple of ladies from Romeo are patiently doing just that. Brookwood also grows tart cherries in July and sweet cherries in August. Their bakery supplies homemade pies to go with those apples in September. (Courtesy of William Bristol.)

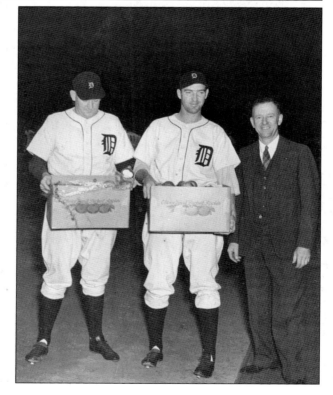

W.K. is presenting Rudy York and School Boy Roe a bushel of apples during a Tigers game. During the 1940s, Brookwood had 120 acres of apple trees and employed local help, older men, and school kids during the harvest season. This picture is displayed in the Bristol Museum located at Brookwood Fruit Farm, 7845 Bordman Road in Almont. (Courtesy of William Bristol.)

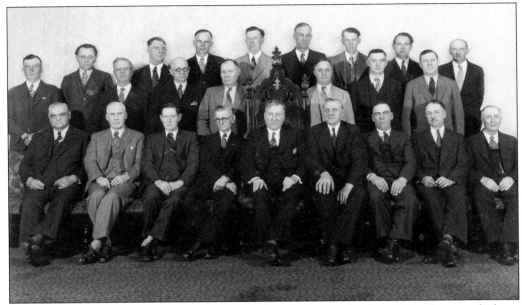

W.K. Bristol was a member of the Mason's Lodge of Almont. In this 1930s photograph, he is standing in the middle dressed in a neat gray suit. As recorded in *History of Almont*, Almont's outstanding Mason was Arthur J. Fox (sitting in the lodge chair); he served from 1908 until the time of his death in 1940. His highest honor, the 33rd degree of the Scottish Rite, was conferred on Fox one week before his death. (Courtesy of William Bristol.)

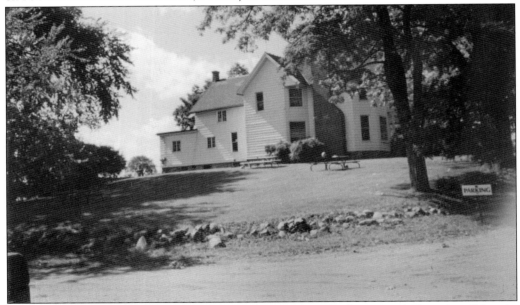

Built in the 1890s, this house is located at 6440 West Bordman Road. Mary and Glenn Averill bought it in 1900. Glenn was a retired Detroit police officer, and Mary worked as chief bookkeeper for Giffels & Vallet, an architectural firm. Glenn was characterized as quiet and unobtrusive while Mary was "mousy and motherly," as described by the *County Press* newspaper. It was said of the Averills that Mary was a fussy shopper and Glenn was a good tipper. (Courtesy of Yvonne Uhlianuk.)

The 150-acre farm included a tenant home. The Averills hired a farm manager for their bustling cattle business. A milk house was constructed with 1920 tile floors, and walls, refrigerators, and stainless steel sinks were installed. The Averills bought a total of 800 acres. Produce from Mary & Glenn Averill's farm populated Detroit's wholesale markets. (Courtesy of Uhlianuk.)

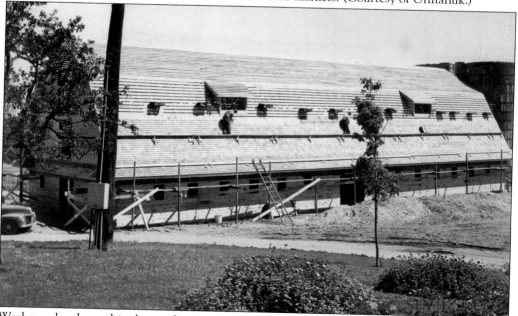

Workmen lay down shingles on the Averill's dairy barn. During the Prohibition years, this dairy facility housed cattle for beef, milking cows, and robust Canadian whisky. The unobtrusive Glenn was a bootlegger who stashed the loot beneath the large stairwell of this massive barn. (Courtesy of Uhlianuk.)

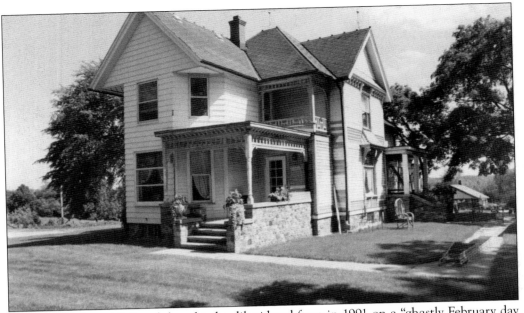

Yvonne and Peter Uhlianuk bought the dilapidated farm in 1991 on a "ghastly February day totally muddy." Local farmhands told Yvonne how the Averills liked to entertain during the Roaring Twenties. Their lavish presents included baby dolls that had a $100 bill placed in each doll's mouth. (Courtesy of Uhlianuk.)

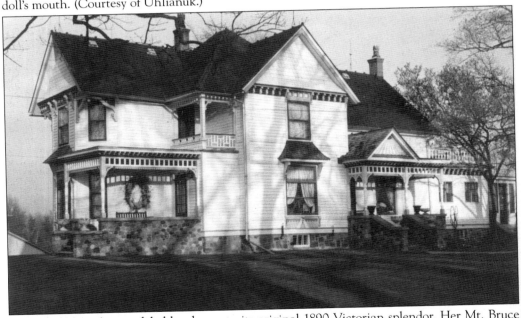

Yvonne Uhlianuk remodeled her home to its original 1890 Victorian splendor. Her Mt. Bruce Station allows tourists to step into a sheepherder's past. Special demonstrations are on the weekend before Memorial Day, the last weekend in September, and the first weekend in December when Yvonne hosts a live nativity scene. The tenant house, now The Farm Wool Shop, is located at 6440 Bordman Road. It provides residents a place to sell their wools. At Mt. Bruce Station, tourists learn how Almont's early settlers used every part of the sheep. (Courtesy of Uhlianuk.)

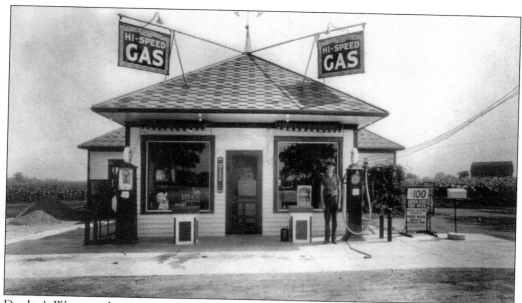

Dryden's Wentworth gas station was located on the northeast corner of Dryden and Rochester Roads. In 1928, Harry Eoff and Clayton Wentworth built this station on the corner of Wentworth's farm. The station remained in the Wentworth family until it was demolished in the mid-1970s. The owners started with Sinclair gasoline, then changed to Hi-Speed and finally to Pure brand. (Courtesy of DHS.)

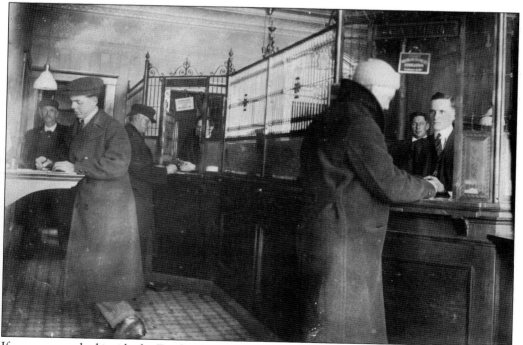

If someone peeked inside the Dryden State Bank during 1930, they would have seen it was always business. From left to right are Bert Hilliker, Floyd Hilliker, Lee Berridge, unidentified teller, Walter Dittman, Floyd Slate, and Ward Peck. (Courtesy of DHS.)

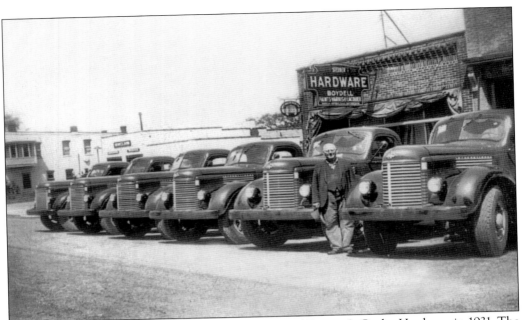

Charles Sterner and his son Kenneth Sterner purchased Easton & Gaylor Hardware in 1931. The purchase included 80 acres of farmland north of Imlay City. A fire destroyed the second floor of this building. (Courtesy of DHS.)

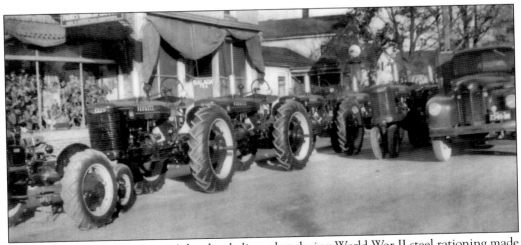

Seeing these rows of tractors, it's hard to believe that during World War II steel rationing made obtaining farm machinery extremely difficult. Farmers ordering tractors had to wait years for their equipment. The tractors would come by train and were unloaded at the depot. (Courtesy of DHS.)

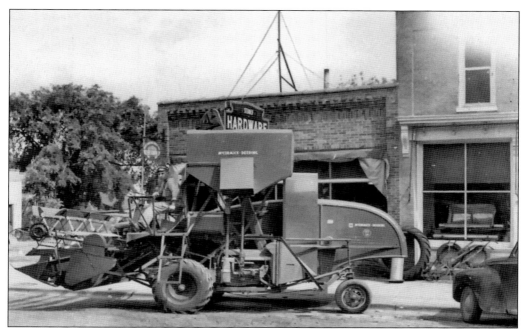

Kenneth Sterner sold the first combine in 1945. Sterner's wife, Anna Mae Kruse Sterner, was the company's bookkeeper. As told in *History of Dryden*, the farmers' wives received Anna Mae very well because she painstakingly wrapped each gift the husbands picked out for their wives with special care. (Courtesy of DHS.)

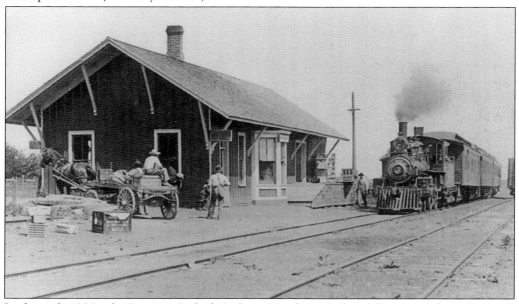

In the early 1880s, the Pontiac, Oxford, & Great Northern Railroad (known as the Polly Ann) asked the towns along the rail route to contribute $1,000 a mile to help defer construction costs. The Ladies Library Association donated $50 from its meager funds and encouraged the citizens to contribute $11,000 toward expenses for the purpose of "cultural freedom for the young men of the town." (Courtesy of DHS.)

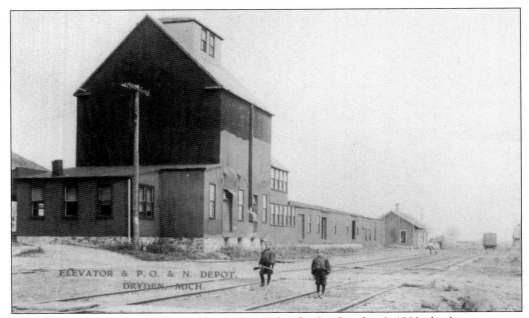

The land for the depot was donated by the Lamb family. On October 3, 1883, the first passenger train rolled into town. Over 500 spectators, a band, and a cannon were there to salute the train. George R. Lamb had his grain elevator built and ready to accommodate the farmers. For nearly a decade, this elevator serviced the community. On July 4, 1897, the elevator and gristmill burned to the ground. In December 1898, Robert Booth built another elevator and sold it in 1906 to Mr. McCollum of Cass City. In 1984, Grand Trunk agreed to sell the rail corridor to the State of Michigan's DNR. In 1993, DNR purchased the corridor for $72,800 with a matching federal grant. The corridor was opened to the public and is now called the Polly Ann Trail. This non-motorized trail is still being used today. (Courtesy of DHS.)

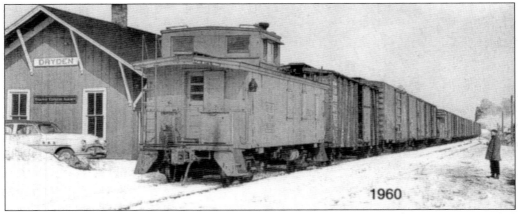

The depot was a 20-foot-by-59-foot structure erected in 1883 at a cost of $2,319. This included the indoor fixtures and an outhouse. It was located on Railroad Street north of Main Street between the Champion building and the elevator. The depot stayed in operation for 90 years. Passenger service was available until 1955, and freight service ceased on October 9, 1973. (Courtesy of DHS.)

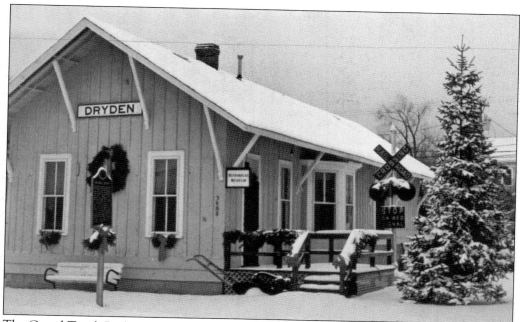

The Grand Trunk Railroad purchased the Polly Ann around 1900. Then Grand Trunk quietly put the depot on the market, setting the stage for "The Great Train Depot Robbery of 1976." Dryden obtained its depot. In 1979, the depot was moved next to the library and became the Dryden Historical Society. Dryden's Fall Festival, always the last Saturday of September, is an event locals and visitors will not want to miss. (Courtesy of DHS.)

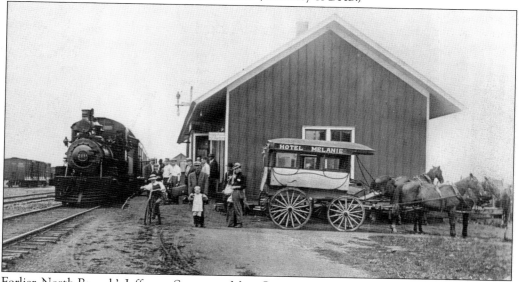

Earlier, North Branch's Jefferson Street was Main Street. When the Pontiac, Oxford, & Northern Railroad was built in 1881 it was located t the east end of the village, but due to some debilitating fires, Huron Street became the business artery. As related in *Pioneer Families and History of Lapeer County*, in 1865, J.M. Melanie had a lumbering business and hotel in Almont. By 1892, the family built another Melanie Hotel at North Branch. Here their coach patiently awaits passengers as the train lumbers to a stop. (Courtesy of NBHS.)

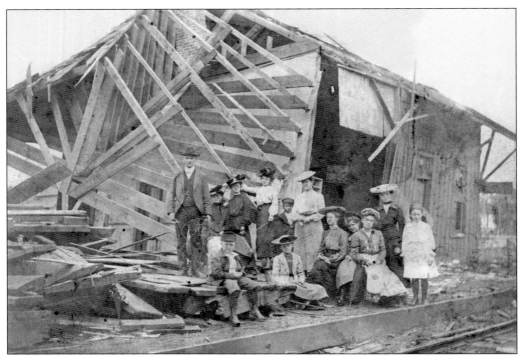

The Pontiac, Oxford, & Northern Railroad Depot was destroyed in 1910 by a "great wind." From left to right are (first row) Guerdon Downer, Laura Stacet, Ruth Barbour, Nell Dutton, and unidentified; (second row) unidentified, Gertrude Draper, Bessie Baldwin, Miss Lilly (a teacher), unidentified, Hazel Clarkson, Gladys Porter, and Kate McDougall. (Courtesy of NBHS.)

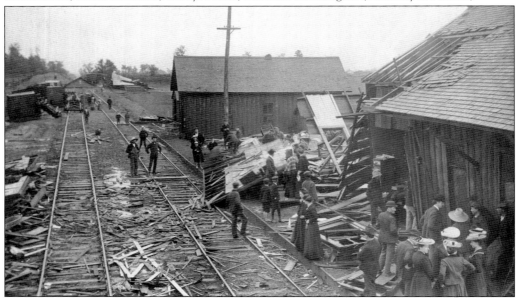

Looking south, this picture shows the terrible damage a cyclone made to the tracks of the Pontiac, Oxford, & Northern Railroad depot. In the early 1900s, it was always a cyclone or "great wind" that destroyed a building—it was never referred to as a tornado. (Courtesy of NBHS.)

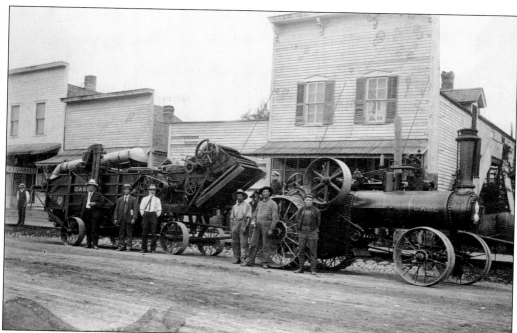

Pictured are a Case tractor and wheat thresher. The building to the right is Daniel Orr's store that was built after the fire on July 12, 1878. It was the birthplace of Dwight P. Orr. Standing in the street from left to right are Hurd Case, salesman; Goss Case, Daniel Orr, John Wilson, John Newcomb, and Bill Gage. (Courtesy of NBHS.)

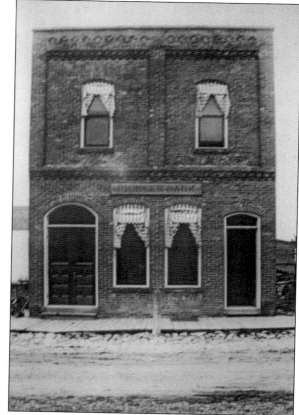

Located at 4021 Huron Street, the Pioneer Bank was organized in 1885 by one of the pillars of the community, Charles "Squire" Ballard. Born in 1845, the Ballards traveled by covered wagon to Illinois and settled in North Branch in 1860. When Charles Ballard passed away in 1977, Frederick Ballard became the bank's president. In 1979, the building was remodeled into early-American décor of exquisite workmanship. Now Independent Bank, the handcrafted American décor is complete with historical pictures of the bygone years of North Branch gracing its walls. (Courtesy of Independent Bank.)

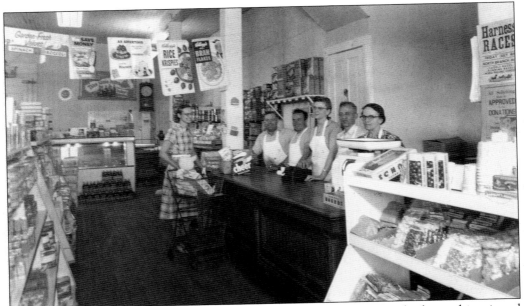

Cheer on the counter, checkered dresses, and clean white aprons are on display at this spit and polish general store. Behind the counter, from right to left, Mary Sutter, Stewart Butterfield, Clarabelle Gates (Bowman), Berard Kohler, and Jim Kohler pose for the camera. The poster on the wall is advertising the racetrack. North Branch had the best racetrack in the thumb. People would come from all around to compete. (Courtesy of NBHS.)

The Orr Store has withstood decades. "Your Grandfather traded at Orrs" has been a slogan throughout North Branch since 1875. Though Orr is a Scottish name, great-great-great-grandfather Andrew Orr Sr. lived in Mullaghbrack, Armegh, Ireland, where he raised his 10 children. Orr Hardware Store is a bustling place to congregate. Daniel S., Clare E., and L. Preston Orr own it. (Courtesy of NBHS.)

William Peter was a German immigrant who eloped with Roxanna Clute. He was determined to prove his father-in-law wrong about him. On April 1, 1887, Peter began a hotel block in Columbiaville called the Marathon House, located on the corner of Walter and First Streets. Mrs. Sara Peter was manager from 1889 to 1895. The hotel included a dining room and drug store. (Courtesy of CHS.)

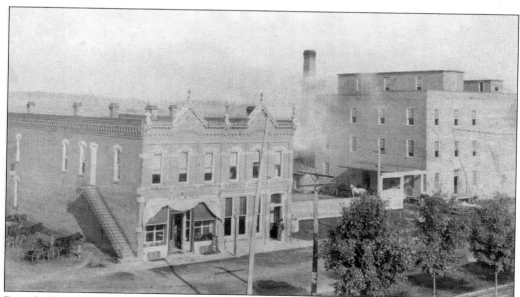

Peter built a store on Lapeer and Middle Streets. It carried groceries, hardware, notions, and dry goods. It was the only store in Columbiaville for 12 years. Peter sold his building in 1879 to John L. Preston. In 1880, Peter built a large general store on First and Water Streets in which he had a private bank. (Courtesy of CHS.)

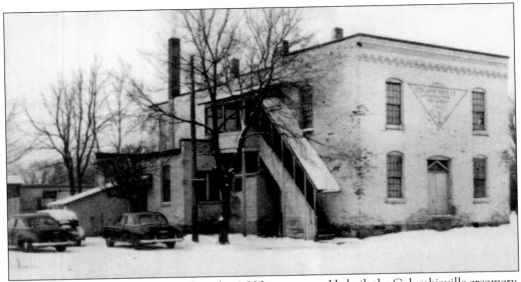

Peter raised Jersey and Durham cattle on his 1,800-acre estate. He built the Columbiaville creamery, located at the west end of Water Street, in 1895. The creamery, used as a cheese factory, furnished his needs and the local farmers'. In 1914, Charles Pelton bought the building and organized the Columbiaville Cooperative Creamery for the manufacture of butter. (Courtesy of CHS.)

Peter had extensive milling operations in Bay City and Toledo. He bought large tracts of land as he trekked through the forests of Michigan and Wisconsin. He made enough money to buy up all the land around Niver Mill and purchased Partridge Saw Mill on the east bank of the Saginaw River. This photograph is part of the T.H. Scott collection. (Courtesy of CHS.)

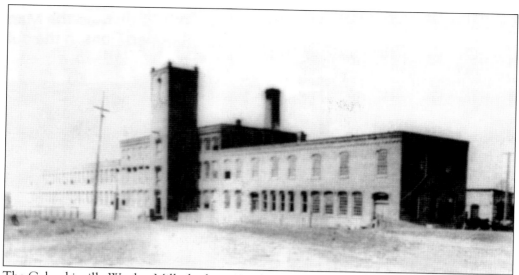

The Columbiaville Woolen Mills, built in 1882 by William Peter, were located on River Street. Peter had large flocks of sheep and so did many other farmers. During the 1890s, the wool industry flourished in Michigan. Over 200,000 pounds of wool were purchased in July 1898, and 150 people were employed here. (Courtesy of CHS.)

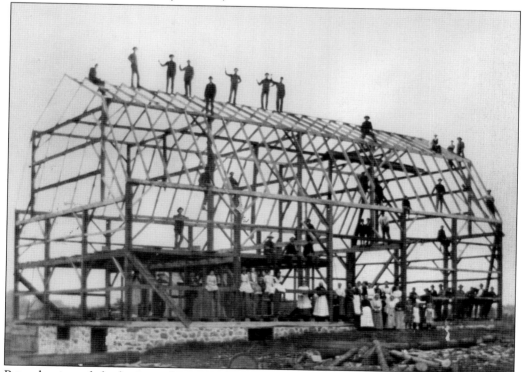

Peter dominated the business district and economic life of Columbiaville, beginning with the gristmill in 1879 and mercantile store and hotel in 1880. With so much property and sheep, he needed a barn. Peter's barn raising took place in 1890 on Lapeer Street at the site of the current Assembly of God Church. (Courtesy of CHS.)

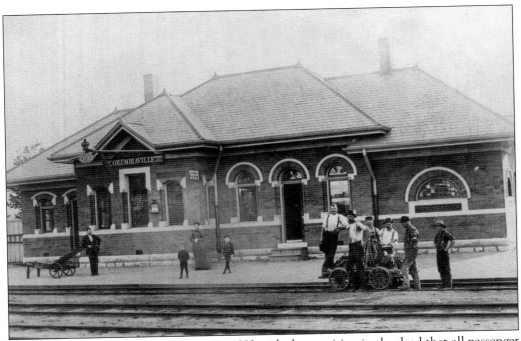

William Peter erected this brick depot in 1893 with the provision in the deed that all passenger trains stop at Columbiaville. Two side tracks near the depot made it easy to switch lines leading to the grist and woolen mill. (Courtesy of Robert Blue and CHS.)

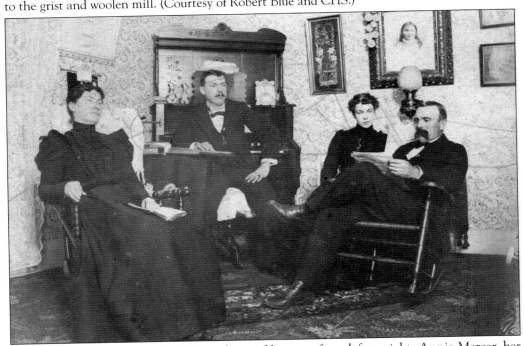

Across from the depot was the Mercer house. Here are, from left to right, Annie Mercer, her son Edgar, her daughter Minnie, and Thomas Mercer. Thomas Mercer served as a marshal for Columbiaville for a while, and also served on the school board. (Courtesy of CHS.)

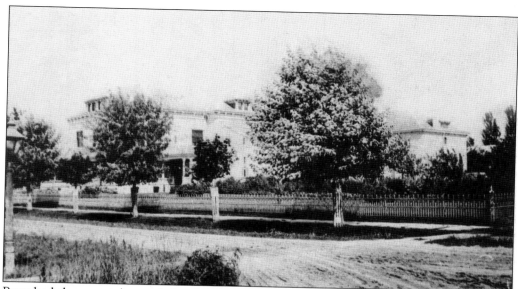

Peter had the money he needed to build a mansion. The mansion's unique architectural style features the cubic Italianate form, which was very popular from the 1850s to 1880s. It cost $65,000. This is a side view of the house and coach house. Toledo workers crafted the home, and the millwork came from Peter's factory. Framed by majestic maples and pines, black wrought iron fencing graces the perimeter. (Courtesy of CHS.)

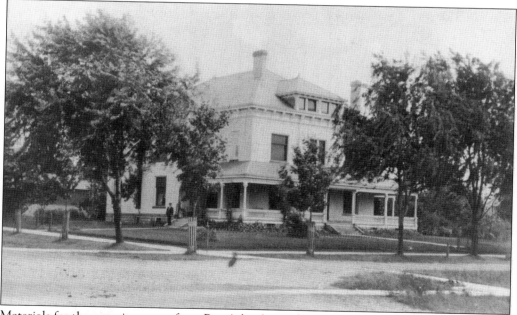

Materials for the mansion came from Peter's lumber yards: the brick for the 18-inch-thick walls came from Peter's brickyard, and stones were brought from Perry Harbor, Ontario, from Peter's quarries. Artists were imported to paint the mansion's interior walls. In 1879, William and Roxanne—in their 70s—moved into their 16-room estate. In the summer of 1899, Peter became ill and died at age 75. Their children Alvin and Harriet were at his bedside. Roxanne lived in the mansion until her death in 1917. (Courtesy of CHS.)

Through time, Peter's mansion turned into low-income housing. In the 1940s, Edward and Leola Calvert bought the dilapidated mansion. Leola refurbished the staircase with its intricately carved newel posts and replaced the broken windowpanes of beveled, leaded glass. Michael Calvert, one of their sons, was the only child born in the mansion. Michael recalls his brother roller skating in the third floor ballroom. He enjoyed playing in the carriage house with its elevator that lifted the carriages to the second floor for winter storage. Michael recalls his mother saying the mansion would be a perfect place for a bed and breakfast. (Courtesy of Teresa Cook.)

The drawing room to the right and the parlor to the left were stained in rich red mahogany. Each room has its own fireplace that included a finely carved wooden mantel. Ceramic tiles of different colors complement the rooms' decors. Now the Historical William Peter Mansion Bed and Breakfast, it is owned and operated by Teresa Cook. She purchased the mansion in the fall of 1998. "Don't Wait till Dawn" is a thriller filmed at the Mansion anticipated to be released in 2014. Dinner theaters, murder mysteries, and comedy plays are part of the bed and breakfast's package. (Courtesy of Teresa Cook.)

Four

CHURCHES AND CULTURE

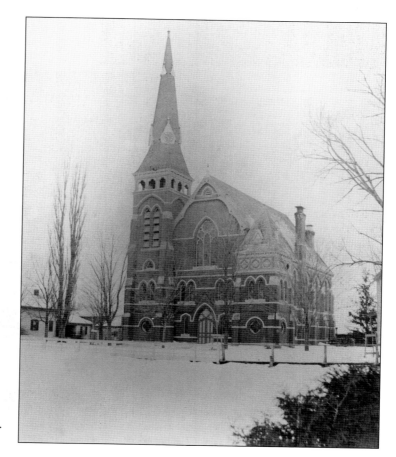

The first religious service in Lapeer County was the funeral of Bezaleel Bristol's infant son in 1829. The Congregational Church is located on East St. Clair and Bristol Streets. (Courtesy of AHS.)

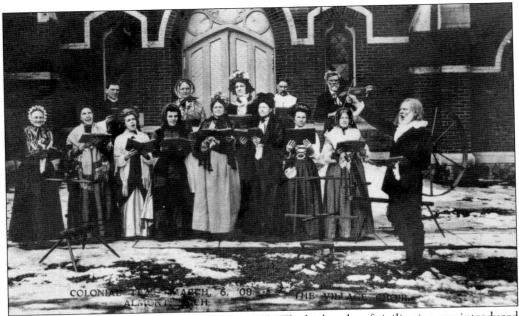

As told in *First Congregational Church, 1875–1975*, "The high order of civilization was introduced into this new country by the early settlers, who came from a land of churches and schools and brought with them a high appreciation of the worth of a Christian intelligence." This picture depicts the Colonial Tea held on March 6, 1908. The village choir is standing in front of First Congregational Church and dressed in Colonial costumes. There is a spinning wheel in the background. (Courtesy of AHS.)

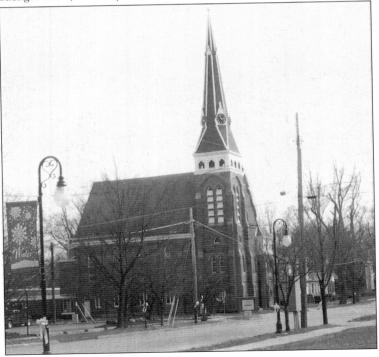

On November 30, 1871, the church burned to the ground due to an overheated stove. A building contract was given to F.P. Currier and Charles Ferguson. Though funds were slow to come, these gentlemen financed the finishing of the church in 1874. On December 28, 1952, the second dedication of the remodeled church was held with Rev. Daniel Boxwell as the minister. Dr. and Mrs. Bishop remodeled the tower room in memory of the doctor's aunt, Jennie Bishop. (Courtesy of AHS.)

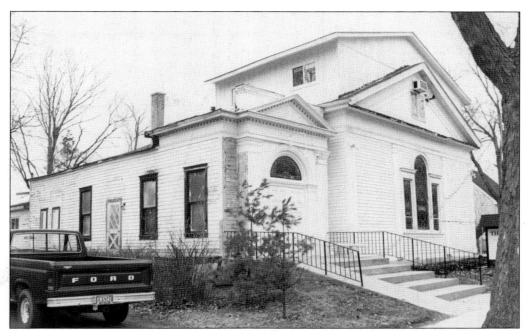

Almont Baptist Church began with 16 members under Rev. Cyrus Churchill in 1837. The place for worship was the home of Edward Hough. In July 1847, the building was dedicated. As told in *The History of Almont*, church needs continued and in 1852 the David Paton family came to Almont from Scotland and gave their last English $20 coin for one of the church seats. (Courtesy of AHS.)

In 1834, the Almont Methodist Church was organized. In 1844 it built its first church on West St. Clair and Church Streets. When it was later torn down, the Hart family built this house with the church's bricks. (Courtesy of David Hurd, AHS.)

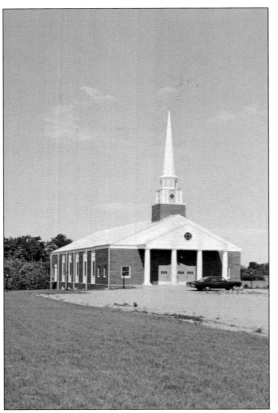

A four-acre site was purchased along M-53, north of the village limit line, and a tent meeting was held that summer. On May 1, 1967, ground was broken for the construction of the new Almont Baptist Church, which cost $200,000. The dedication was September 29, 1968. It was the largest church in the state to be electrically heated. (Courtesy of AHS.)

The pioneer's life gradually eased and there was time to enjoy the lighter side of life by the early 1900s. Almont's Municipal Band was organized in 1908 with Henry Slating as director. They played at Almont's first homecoming in 1909. Roy, Oliver, and George Bristol are labelled on this photograph. Dr. Parkin, William Muir, Ray Howland, Tom Sawyer, and Carl and Hugh Johnson were also in the band. (Courtesy of Phillis Bristol.)

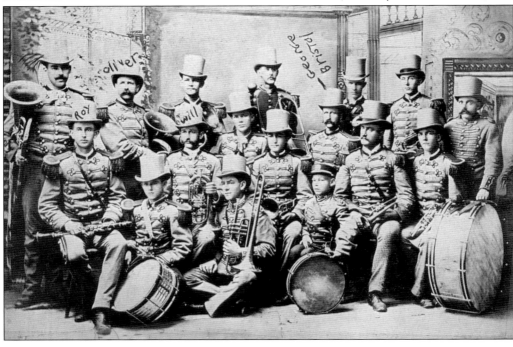

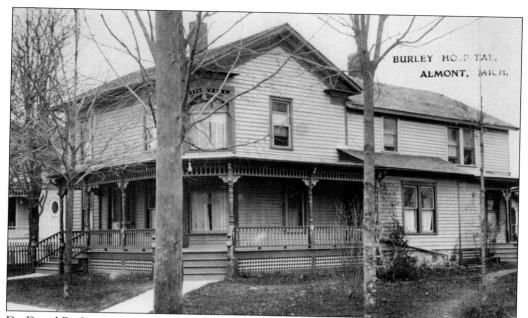

Dr. David Burley was born in Thetford, Ontario, in 1863 and came to Almont on June 21, 1893. He traveled by horse and buggy and kept four horses ready for use, changing horses with every call. With his brother Dr. Jacob Burley, he started Almont's first hospital. It is now a residence located at 124 West St. Clair. The house in the background was once where Railway Depot sat. When automobiles became popular, Dr. Burley bought a 1910 Carter. (Courtesy of AHS.)

The last week of June 1953 was proclaimed Dr. Burley Week and marked the 60th anniversary of Dr. Burley hanging out his shingle. Villagers contributed to the doctor's dream: a 50-bed hospital. Dr. and Mrs. Burley nostalgically arrived in a buggy. In *The History of Almont*, Dr. Clare Bishop wrote, "Dr. Burley has been faithful to both God and man and he has been a credit to his profession." (Courtesy of AHS.)

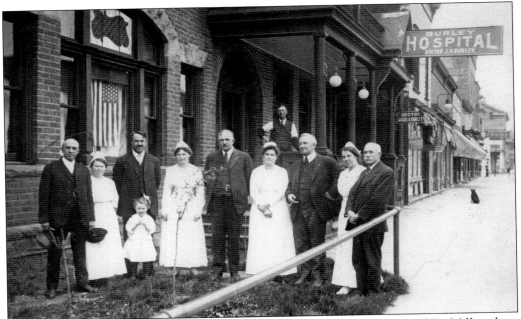

Here is Dr. David Burley (far right) Dr. Letts, Dr. Jacob Burley, Dr. Shinfox, and Dr. Miller, along with their nurses. Dr. Burley brought 5,000 babies into the world, with some of those being twins. He passed away on April 20, 1959, at 95 years old. He had been a faithful member of the Congregational Church for 61 years. The building stands on South Main Street and is presently the Muir Funeral Home. (Courtesy of AHS.)

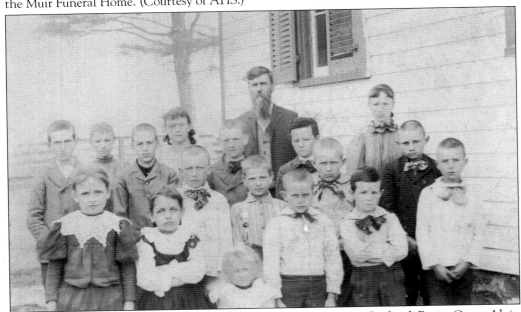

Teacher James Hamilton stands behind students Don Mosser, Mary Borland, Berita Coan, Alvin McCampbell, Elva Wallace, Cass Braidwood, Frank Braidwood, Tommi Borland, Peter Braidwood, Fred Braidwood, Mabel Muir, Arthur Borland, Janet Borland, and Janet Burland. Lucie Hough supplied the student names and picture. (Courtesy of AHS.)

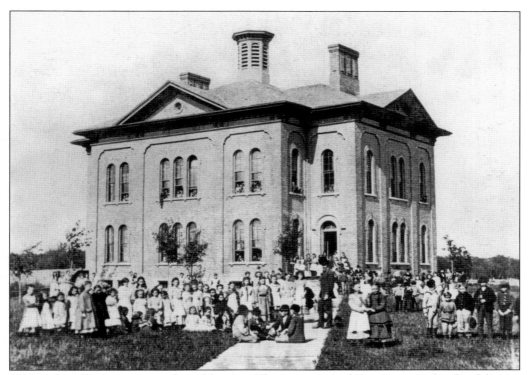

Within the villages were a number of districts. These were united, forming a single school district with a single school named Union School that originated in 1867. The first brick two-story building was built in 1867 and burned down on Friday, December 9, 1881, due to a fire in the furnace room. The cost of the loss of the school was determined to be $17,000. (Courtesy of Paul Bowman.)

A new Almont Union School was built to replace the school that burned in 1881, opening on April 14, 1884. Annie Paton Swain said about her favorite teacher, Miss Amelia Dickerson, for 30 years she taught "paths of wisdom." There was no kindergarten then. She had beginners and first and second graders in one room. Children brought their lunches and lesson materials. This school burned to the ground on April 18, 1927. (Courtesy of Paul Bowman.)

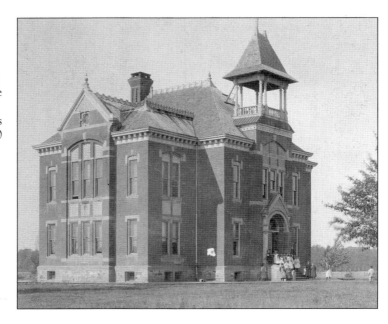

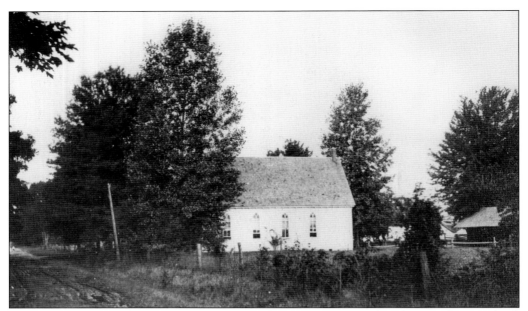

As told in *History of Almont*, in 1840, William and Jean Downie Hamilton from Paisley, Scotland, wrote about Almont's Scotch Settlement and their New Church to relatives. This brought more Scottish settlers to Almont after the Civil War. The New Church was located on the corner of Tubsprings and Cameron Road. (Courtesy of Eunice Hamiltion, AHS.)

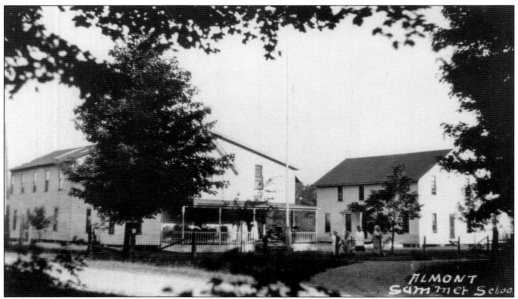

Progress was sweeping through Almont and young people were feeling it. By the late 1890s, the elderly people of New Church were becoming concerned about the "drifting away of the young people." Rev. Eugene Schreck of the Detroit Society suggested a summer school at the church. (Courtesy of AHS.)

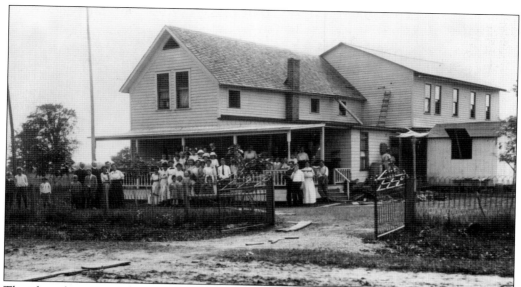

The idea of an Almont summer school materialized and it was decided that Reverend Schreck and his wife would teach it. The young ladies slept at neighboring farms while the boys stayed in tents on the church grounds in 1899. The summer school had its first opening session that same year. It was a huge success and next year a cottage was built. Families came from Michigan, Ohio, Pennsylvania, and Illinois. (Courtesy of AHS.)

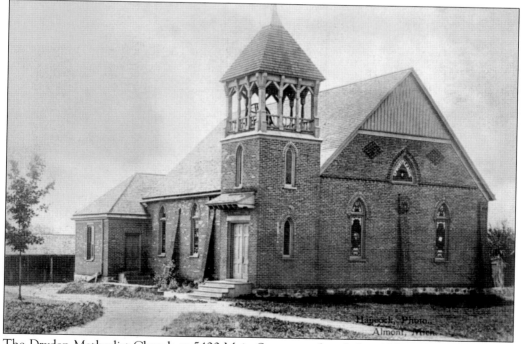

The Dryden Methodist Church at 5400 Main Street was founded in 1854. It began with Rev. Abel Warren of Washington riding in on horseback and holding his sermons wherever open space could be found. For 35 years the "Old White Church" continuously grew. A larger, more modern church was eventually built. (Courtesy of DHS.)

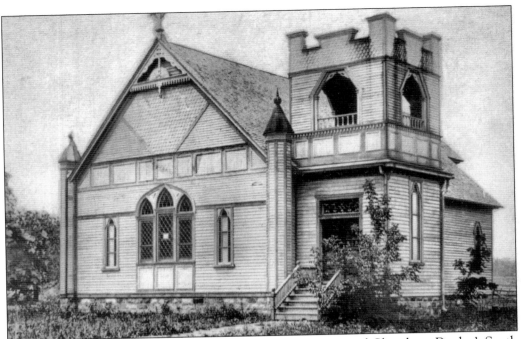

In 1896, a "stone bee" began the foundation of St. John's Episcopal Church on Dryden's South Mill Street. The Rev. Frederick Hall donated the tract of land. The ladies provided meals for the men who delivered stones for the church's foundation. (Courtesy of DHS.)

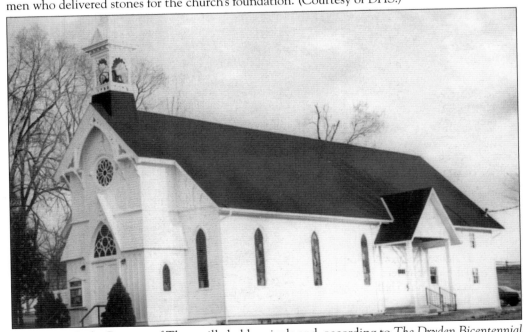

Built in 1847, the Baptists of Thornville held revivals and, according to *The Dryden Bicentennial Book*, they were on "hell, fire and brimstone." In 1885, the congregation decided the little church needed remodeling. The original Bible used during those revivals still holds a place of honor in the faithful little church. (Courtesy of DHS.)

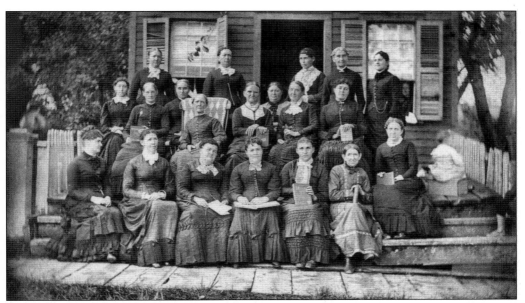

The Dryden Ladies Library Association of 1878 to 1879 is pictured here from left to right: (first row) Rae Emmons Lamb, Pricilla Ricey, Helen Clark Hemingway Lamb, Barbara Morton Bredin, Maria Hall, Patty Emmons, and Marietta Harris; (second row) Ella Snover Manwaring, Caroline Lamb, Anna Elizabeth Bartlett, Mary Lamb Hodson, Charlotte Hinks Hall, Phidelia Foot Kendrich, Harriet Randolph Darwod, and Mati Starmer; (third row) Anna Randolph Rupert, Rebecca Emmon, Maria Gray Foot, Lucy Lamb (from New Jersey), and Carrie Day Lamb. The child on the box is Clytie Foot. (Courtesy of DHS.)

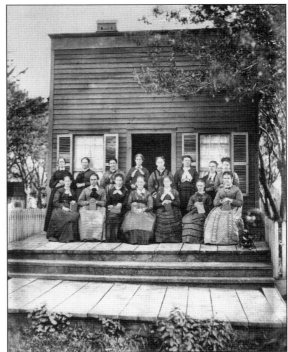

Dryden's first library was called the Little Brown House. The Library Association was organized in March 1871. Active members were married ladies only; the yearly fee was $1. The library started with six books. When the ladies held meetings, they sat in the rocking chairs that are still in the library today. Pictured here are, from left to right: (first row) Caddie Lamb, Anna Eliza Bartlett, Ella Manwaring, Charlotte Hall, Sophia Emmons, Lucretia Lemmons, and Anna Randolph Rupert; (second row) Mary Lamb Hodson, Harriet Darwood, Mary Booth, Mary Porter, Eunice Bacon, Lillie Ulrich, Martha ?, and Frances McNeil. (Courtesy of DHS.)

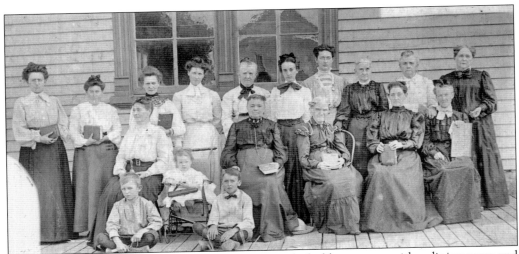

Dryden's new library was finished in 1889. It consisted of a library room with a dining room and kitchen on the first floor. The second floor had a hall with a stage, and the stage backdrop was a picture of a dirt road in Dryden in 1889. This 1912 photograph shows its members: from left to right in the first row are Fanny Snover, Cemantha Ulrich, Charlotte Hall, Ella Manwaring, and Sadie Braidwood; in unknown order in the second row are Ada Williams, Alice Maynard, Mary Porter, Anna Rupert, Lillie Ulrich, Allie Parker, Julia Maynard, Matilda Balch, Lydia Lamb, and unidentified. The children are Harold Foot, Pauline Porter, and Earl Ulrich. (Courtesy of DHS.)

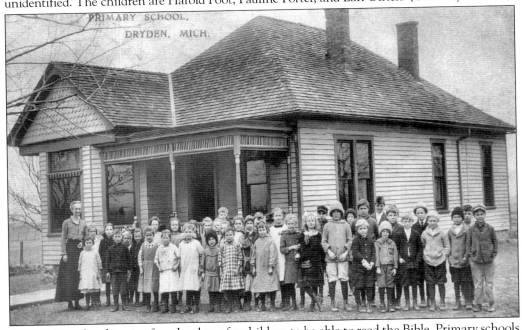

At one time, the objective for school was for children to be able to read the Bible. Primary schools constituted the elementary grades, but children were not required to go to school. Responsibilities to help with farming chores or care for younger siblings often kept them home. Poor children or orphans worked in factories as cheap labor. If they were of the privileged few who went to school, the boys sat on one side of the room and the girls on the other. Older children helped with the care and teaching of the younger students. (Courtesy of DHS.)

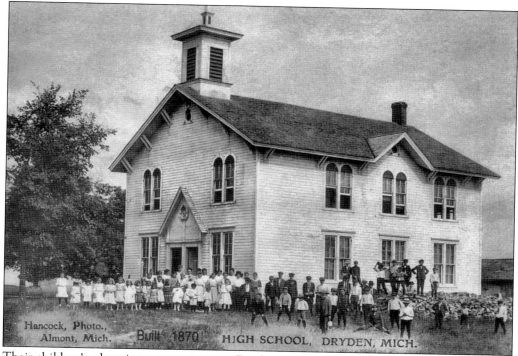

Their children's education was a priority to Dryden residents. In 1870, the Dryden High School was built, costing $4,000. As told in *History of Dryden*, "A school house was built which creates a feeling of pride and responsibility as one enters. It's a feeling one often notices in entering a bank or post office but very seldom in entering a schoolhouse." (Courtesy of Hancock Photos, DHS.)

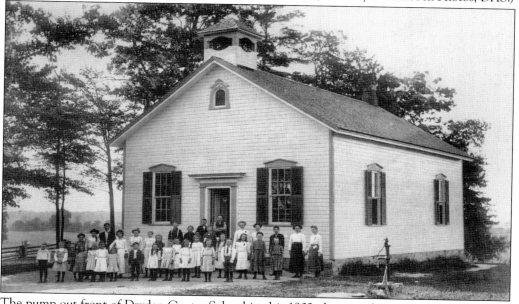

The pump out front of Dryden Center School in this 1903 photograph indicates that there was fresh water for drinking. If the school did not have a pump, one student would be designated to bring a pail of water for the students to drink from. (Courtesy of DHS.)

In 1837, along with Michigan's statehood, a colony formed with counties to the south and southwest that was part of the Dryden Township. Joel Dudley, James and Washington Allen, Stephen Grinnell, John and James Phelps, James Deming, Robert and Uriah Townsend, and Jacob Moore, most of whom were Whigs, settled in this area. This settlement became known as Whigville. In 1906, Dryden's Whigville School was located at 3735 Hough Road and Glen W. Slade was the teacher. (Courtesy of DHS.)

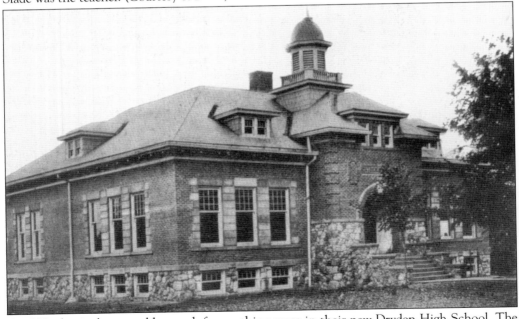

In 1908, the students could not ask for anything more in their new Dryden High School. The sky was the limit for those graduating from this beautiful stone building. The curriculum steadily increased and an athletic department was added. (Courtesy of DHS.)

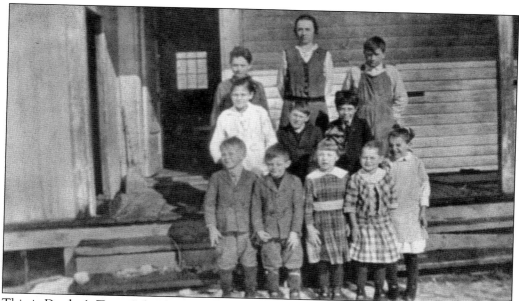

This is Dryden's Terry School in 1909. From left to right are (first row) Roy Richman, Paul Hillman, Clare Mae Foe, Mildred Brooks, and unidentified; (second row) Myrtle Stepnitz, Alphred Todd, and Russel Hillman; (third row) Clarence Trott, Maude Smith (teacher), and Frank Trott. (Courtesy of DHS.)

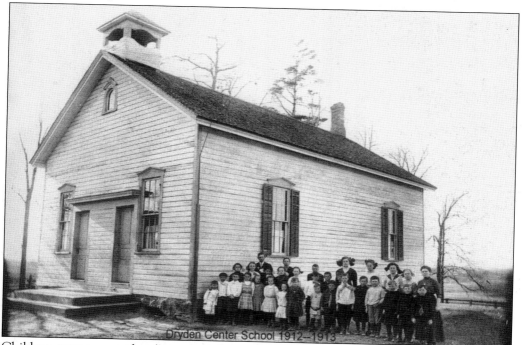

Children were expected to know their lessons. Books were scarce and students spent hours memorizing from textbooks and the Bible, and then reciting before their teacher. Dryden's Center School was no exception. Pigtails were all the rage back in 1912, as seen on these girls. (Courtesy of DHS.)

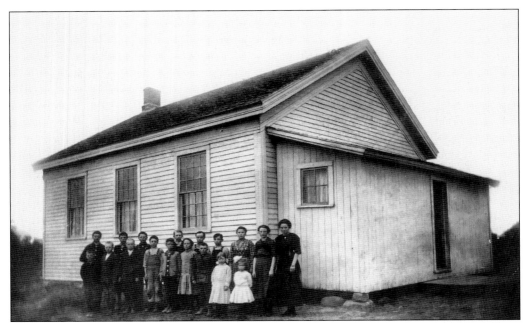

Dryden Day School was located on Dryden Road, about one-and-a-half miles west of the village. This picture was taken in 1919. It was customary for the older students to help the younger with their studies. The two pretty little girls dressed in the angel-white dresses will have plenty of volunteers. (Courtesy of DHS.)

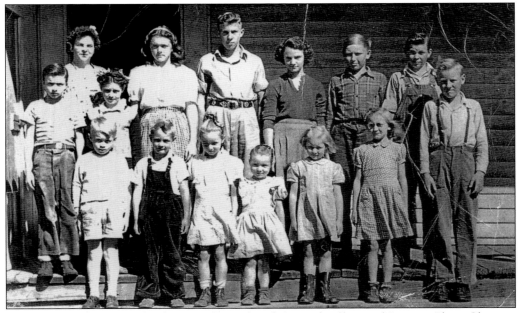

In 1946, Dryden's Terry School picture shows, from left to right: (first row) Laurene Place, Clarence Lee Trott, Eileen Balfour, Earletta Balfour, Marion Boseh, Christine Boseh, and unidentified; (second row) David Balfour and Ola Bell Brooks; (third row) Mrs. Gerald Smith (teacher), Joyce Balfour, Ed Ostrum, Luella Bevoks, unidentified, and Dale Smith. (Courtesy of DHS.)

Pictured are the students of Dryden's Terry Elementary School in 1946, from left to right: Christine Bosch, C. Lee Trott, Ola Bell Brooks, Danny Trott, Marion Bosch, Carol Ann Jewel, and Jimmie Thomas. Not shown are teachers Mrs. Vandewalker, Mrs. Hosmer, and Mrs. Smith. (Courtesy of DHS.)

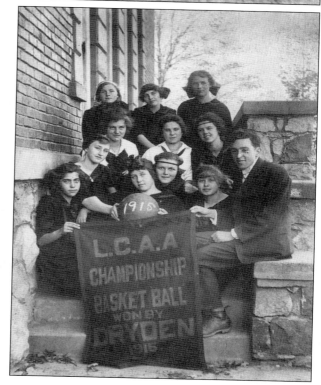

The Dryden girls' basketball team made the championships in 1914 and 1915. From left to right are: (first row) Blanche Wilson, Martha Wilson, Ruth Hull, and unidentified; (second row) Nora Dittman and Fern Utley; (third row) Zella Newman, Ruth Butts, and Hilda Haynes; (fourth row) Mable Kruse, Mable Blow, and Lucille Whitaker. (Courtesy of DHS.)

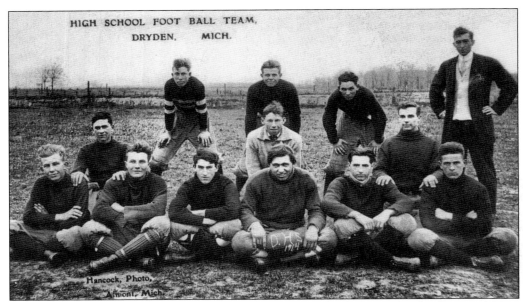

Dryden's football team did not do so poorly themselves. From left to right are: (first row) Vern Clark, Orneldo Utley, ? Walton, Harold Foot, Leon Foot, and Don Walton; (second row) Stimson Travis, Alden Haynes, Grant Newman, and unidentified; (third row) Lester Wells, Fred Harmer, and Homer Butts. (Courtesy of DHS.)

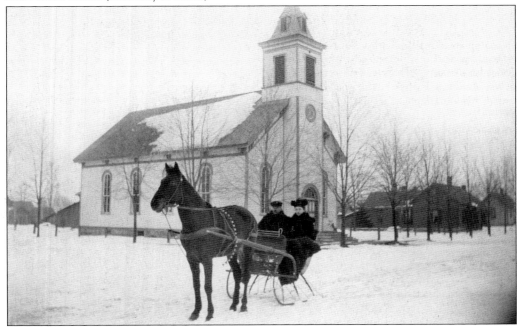

On a frosty day, the Reverend and Mrs. Crosby of North Branch sit in a one-horse sleigh in front of Maple Grove Church, then located on Slattery Road on the southwest corner of the cemetery. Rev. Reuben Crosby served as pastor for the Maple Grove and United Methodist Church. His relative Fanny Crosby wrote many famous hymns. The Methodist church was later moved. (Courtesy of NBHS.)

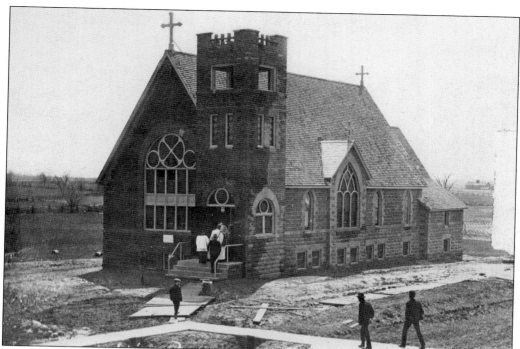

As told in *History of North Branch 1855–1955*, the beginning of St. Peter & Paul's Roman Catholic Church dates to 1906 when the cornerstone was laid. The church was completed in 1913. Father Witteman served 14 years, Father Burke served nine years, Father Coughlin served six months, Father Koelzer served six years, Father Laige served three years, Father Gallagher served three years, and Father Curran served six years. Father Sobezak came in June 1952. (Courtesy of NBHS.)

The First United Methodist Church in North Branch started in a home in 1855. In the fall of 1856, the church relocated to the corner of Banker and Sherman Streets. Some history was lost due to a fire. The church was rebuilt in 1870 on the bustling and thriving Huron Street. This historical monument holds guided tours during North Branch's Fourth of July celebrations each year. (Courtesy of NBHS.)

Charles Ballard, president of Pioneer Bank, built this house and later sold it to Blackburn. During the 1800s, people laid out their loved ones in their parlor and removed them through a specially built door, called "Death's Door," not allowing the living to follow the dead. In the 1920s, customs changed and people encouraged the undertaker to lay out the body at his premises. Blackburn Funeral Home began with Isaac and his two sons Arthur and Stanley. They took ownership when their father died. Arthur passed away in 1935. (Courtesy of Kelly Martin.)

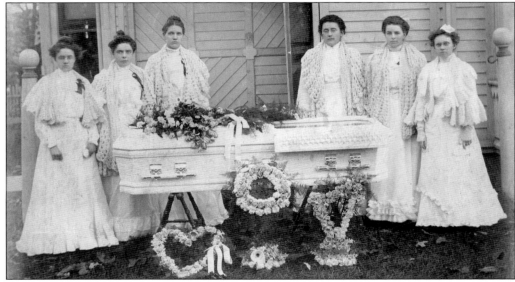

Dressed not in black, but white, these Columbiaville ladies are standing in front of a partially opened door at what looks to be their home. Is this door "Death's Door"? Not all the ladies are identified. However, three of them are Margaret Jamison, Daisy Hollenbeck Hessensaw, and Martha Craig Traver. (Courtesy of CHS.)

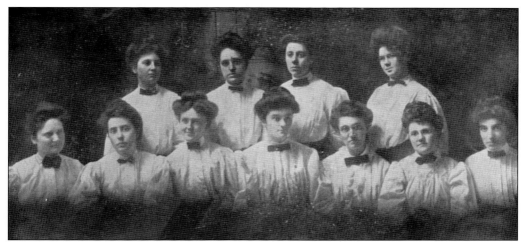

Pictured here are North Branch's Leap Year Girls, from left to right: (first row) Edith Harrington, Dora Schell, Myrtle Elliott, Dot McCormick, Myrtle Giyshaw, Mildred Winn, and Nellie Smith; (second row) Jenney Finkle, Mildred Orr, Mary Langdon, and Gertrude Draper. (Courtesy of NBHS.)

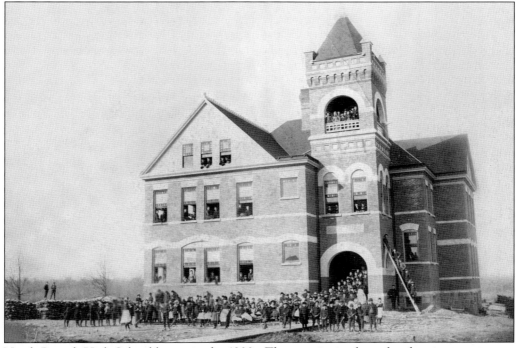

North Branch High School began in the 1800s. The upstairs is where the chemistry room was. Instead of cement, the sidewalks are wooden. The students paid for tuition by the cords of wood they delivered. The stacks of firewood are to the left. Every window is filled with students, with the boys on a stepladder. Thelma Castle (Crawford) remembers that when the wind blew hard, she could feel the third floor sway. Later, they built a stone wall to support the third floor. (Courtesy of NBHS.)

Along with Coach Philip Marazita, the boys shared moments of their first season in their new North Branch High School gymnasium with their happy parents and fans. This is a picture of the first toss-up of the season in the new gymnasium on November 29, 1963. The seniors were Karl Krepps (team captain), Ralph Margrif (most valuable player), Dennis Bugg, Marty Crawford, Bob Acker, Fred Monroe, and Danny Byers. (Courtesy of NBHS.)

North Branch was the conference champion in 1964. From left to right are (kneeling) Mike Griswold, Melvin Roe, Evan Bradley, Denny Smith, Gary Currell, Dave King, L.C. Curtis, Art Pederson, Dale Rhode, Bob Wells, Ron Simpson, Joe Scrimger, and George Serimger; (standing) Coach Therin, Dennis Anderson, Lee Mathews, Brian Hagemeister, Karl Krepps, Larry Ball, Ron Hicks, John Hogan, Jim Robinet, Jim Bard, Dwayne Morse, Neil Sealy, Bob Acker, and Coach Bogar. Not pictured are Rich Rechow, Cass Regnolds, Scott Ward, John Burnette, David Castle, and Philip Noyes. (Courtesy of NBHS.)

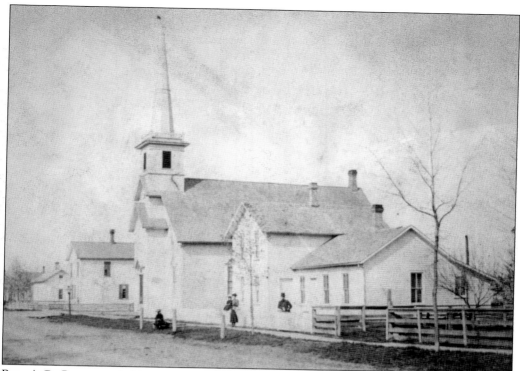

Rev. A.C. Carpenter held sermons in the 1850s in this Columbiaville Methodist church. The building for the parsonage began in 1865, and it was located at 4420 Pine Street. The oldest record of church membership was Mrs. Ahijah Willey. The church was struck by lightning but another church was built in 1896. (Courtesy of CHS.)

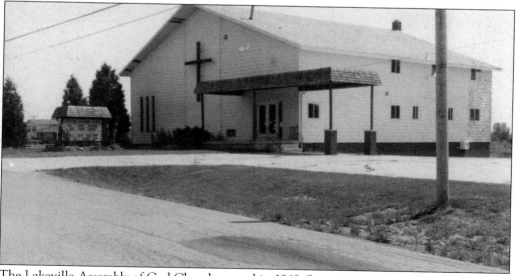

The Lakeville Assembly of God Church started in 1949. Street meetings were held at First and Water Streets. In 1953, property was procured at 4349 Lapeer Street with Rev. Harold McMullen as the founding pastor. This picture is of the Assembly of God Church located on the site that Peter's barn once stood on. (Courtesy of CHS.)

The Columbiaville Opera House was located on the southwest corner of Water and First Streets. It was a huge social event in the late 1800s, as seen in this picture taken April 25, 1899. (Courtesy of CHS.)

A play may have just finished at the opera house. Front and center is Ella Munroe Leisaw, and the man in the back of Ella with a top hat is Bill Leisaw, her husband. The others are unidentified. (Courtesy of CHS.)

This could possibly be another skit done at the opera house. Dr. C.W. Chaplin is on the left and Bert McDermid is on the right. Chaplin was a captain in the Medical Corps during World War I. (Courtesy of CHS.)

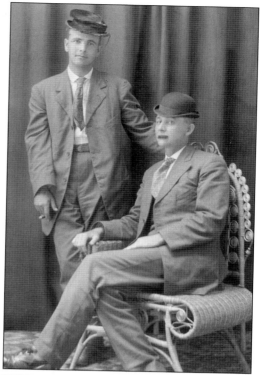

The youngsters below attended Schott School in 1908 and were taught by John Potter. From left to right are: (first row) James Hemingway, Glen Moore, Fred Baker, Henry Hemingway, Alvah Thompson, Harry Thompson, Everett Hemingway, Jimmy Potter, Edgeworth ?, Louse Larkin, Vina Moore, Erma (Lewis) Brown, Ann Potter, Florence Hill, and Edna (Thompson) Larkin; (second row) Mr. Potter, Charles Thompson, Cecil Larkin, Howard Stoddard, Eddie Jones, Willis Griswold, Grace (Coe) Robison, Olive (Schott) Sammons, Florence (Moore) ?, Eddie Jones, Willis Griswold, Grace (Coe) Robiso, Olive (Schott) Sammons, Florence (Moore) ?, Verne (Moore) Everhart, Neta (Jones) Thompson, and Vida (Edgeworth) ?. The sign in front says "Dist. No. 8, Marathon." (Courtesy of Mrs. Earl Clute, Erma (Lewis) Brown, and CHS.)

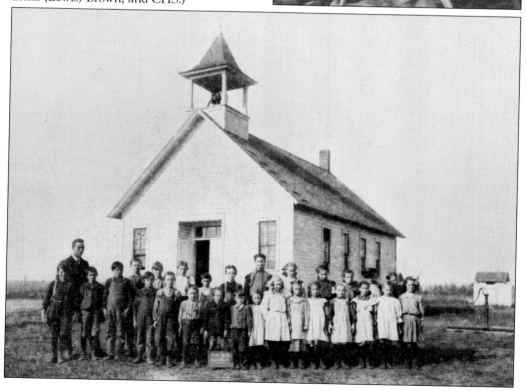

The Columbiaville LaValley School class of 1920–1921 is pictured from left to right: (first row) Dazie Sweet, Gordon Welch, Vernon Parks, Edward Vanderliys, Hersey Welch, Cecelia Benedict, Clayton Hurchins, Margaret Olney, Edith Harvey, Eula Sweet, Jean Dungam, Velda Ross, and Hazel Gerard; (second row) Dorothy Kile, Melvin Porrett, Edward McGunegle, and Natalie McGunegle. In unknown order in the third row are Ralph Parks, Gelma Ross, Erma Clohs, Gladys Kile, Della Olney, Keith Dungan, Reva Kile, and unidentified. (Courtesy of CHS.)

The Columbiaville High class of 1935 is pictured here. Among those pictured are Russell Nichols, Richard Jones, John Crawford, George Lee, Ronald McDonald, Joseph McDonald, Keith Seaman, Randy Ballger, Miss Thibaret, Betsy Vermelya, Margaret Smith, Lucille Miller, Georgia LeValley, Mary Jane Pearce, Donna Lawrence, Catherine Treine, Helen Whipple, Mr. Michelle (superintendent), Virginia Thorn, Irene Hastle, Margaret Roman, Doris Brandt, Iva Abbey, Bernetta Barber, Diris Morrison, Helen Trader, Maxine Smith, Miss Stansfield, Helen Butler, Roma Burse, Jene Whitdone, Hazel Benedict, Doris Ross, Helen Metrolf, Christine Schadt, Katherine Schadt, Barbara Robertson, Catherine Glassford, Gladys Burgess, Jane Robertson, Anna Schann, Jessie Leland, Nina Dockham, Miss Morton, Mr. Schelke, Lester Younker, Cyde Pyles, Carl Hibbert, Kenneth Smith, Edward MacIntyne, Robert Warser, James Tebberts, Arthur Burgers, Donald Conghams, Floyd Skinner, Donald McArthur, Earl Genard, Anthony Abbly, George Rook, Howard Booth, and Robert Skinner. (Courtesy of CHS.)

Five

COMMUNITY PRIDE

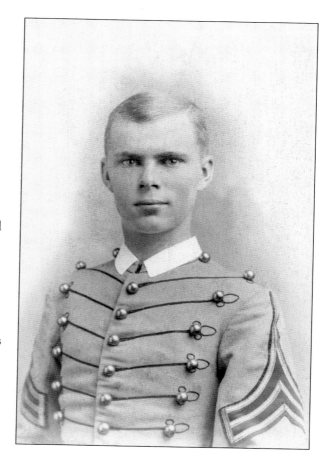

George Owen Squier of Dryden graduated from West Point, ranking seventh in a class of 65 students, and was appointed second lieutenant in the 3rd Artillery. Squier's class book describes him as "easily the outstanding genius of the Class of 1887." With the sinking of the *Maine* in 1898, Squier directed a cable system from the cable ship *Burnside* to improve communications in the Philippines. Returning from the war, he studied aviation, and in 1907, began specifications for an airplane. Squier was the first passenger the Wright Brothers carried in their experimental airplane. (Courtesy of DHS.)

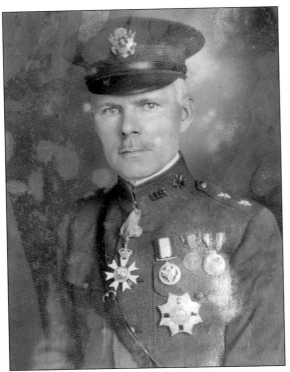

Squier graduated from Johns Hopkins University. Through his scientific endeavors in 1909, Squier discovered "wired wireless," wherein over a dozen messages were guided along a telephone wire. When war broke out in Europe in 1912, Squier aided thousands of American tourists back to the states. He plunged into the trenches for three months, risking his life for the experience of knowing what to teach future soldiers. He died March 12, 1934, at 69. This good old country boy gave his countrymen peaceful harbors and "a new leisure" in more ways than just Squier Park. (Courtesy of DHS.)

Price Vanderbilt Yoder (1879–1957) originally came from Canada. He fought in the Spanish-American War in 1898 for Michigan's 33rd Unit, Michigan Infantry. At the time, he was 19 years old. He married Mabel Bristol and settled in Almont. (Courtesy of Phillis Bristol.)

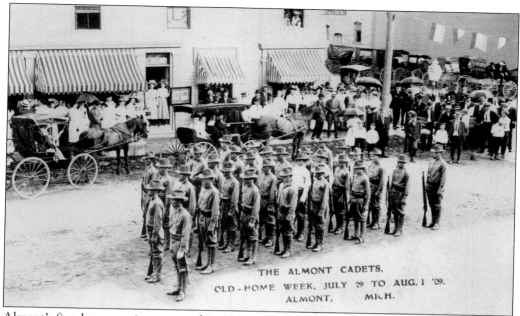

Almont's first homecoming occurred in 1860, with the raising of the Liberty Pole in honor of the end of the Civil War. The Almont Cadets met the visitors at the outskirts of the village and marched into town with them. Then the Cadets, dressed in military attire, marched proudly behind the band. They are pictured at the corner of Main Street and what is now West St. Clair Street. Hancock Shop is on the corner. (Courtesy of AHS.)

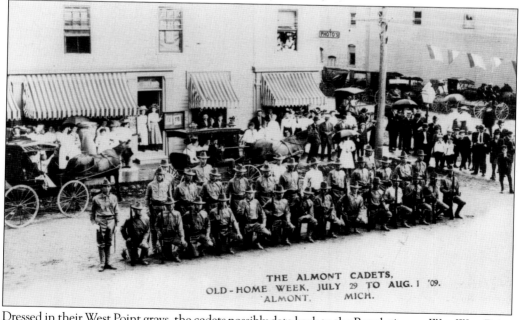

Dressed in their West Point grays, the cadets possibly date back to the Revolutionary War. West Point graduates dominated the ranks of officers during the Civil War. Generals Grant, Lee, Sherman, and Jackson were all graduates. The development of technical schools during the post–Civil War era allowed West Point to broaden its curriculum. (Courtesy of Paul Bowman.)

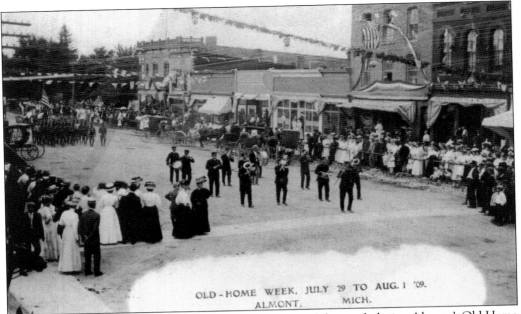

OLD - HOME WEEK, JULY 29 TO AUG. 1 '09.
ALMONT. MICH.

This image is looking up the east side of Main Street toward the north during Almont's Old-Home Week, Pioneer Days. Eleven states were represented as well as Canada. Residents opened their homes for the visitors, and special car of visitors came out from Detroit. Almont's band marched forward with the cadets just behind them. (Courtesy of by AHS.)

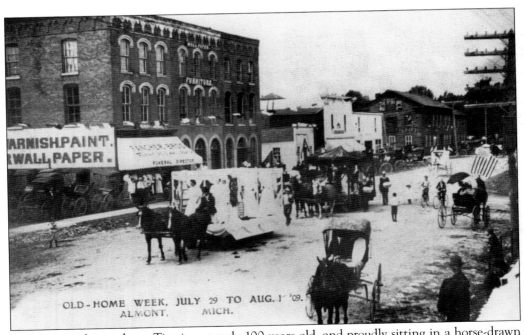

OLD-HOME WEEK, JULY 29 TO AUG. 1 '09.
ALMONT, MICH.

One pioneer featured was Tip-si-co, nearly 100 years old, and proudly sitting in a horse-drawn carriage. Tip-si-co spent Sunday in the Methodist Church. He sang three songs in his native tongue and then stood up before the congregation and gave a short talk. (Courtesy of AHS.)

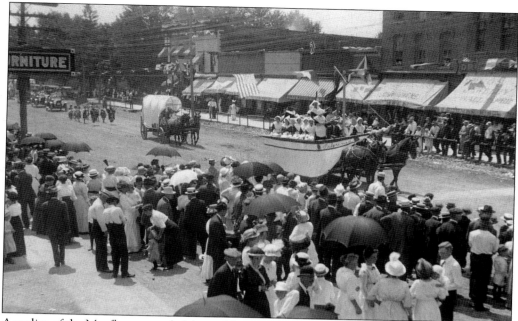

A replica of the *Mayflower* traveled down Almont's Main Street in this 1914 homecoming parade. Two Almont families, the Bristols and the Bishops, can trace their ancestry to the Pilgrims who came over on the *Mayflower*. The bagpipes of the marching Scotsmen fill the sunlit air with the poetic music of this deeply Scottish community. (Courtesy of Paul Bowman.)

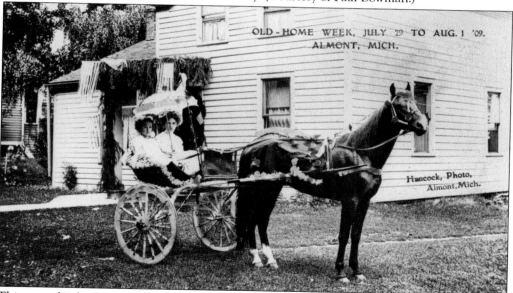

This two-wheel surrey is awaiting the parade for Old-Home Week held from July 29 to August 1, 1909. Sitting in the surrey on the right is Belle Bowman, and on the left is Olive Vellian Touse. The Killiam House is in the background. Almont's Heritage Festival is now every third weekend in September. The old post office is now the Almont Historical Society. There, the nostalgic memories of flowing laced dresses and ladies clad in white gloves holding pretty parasols continue. (Courtesy of Hancock, AHS.)

In 1957, the Lapeer Posse was formed under Sheriff Bill Porter (standing). It began with nine members: Ed D'Arcy, Keith McGregor, Dr. Bill Mackie, George Juhi, Irvin "Red" Brooks, Mel D'Arcy, Milt D'Arcy, Cliff Keefer, and Albert Hall. This 1960s photograph shows from left to right: Ed D'Arcy, Keith McGregor, Red Brooks, Clayt Kellogg, Sam Heron, Willard Driskell, James Ortman, Jack Miller, George Juhi, Clifford Keefer, Melvin D'Arcy, Bill Dunbar, Det Steward, Eldon Barclay, Dr. John Thompson, Elton Arms, and Milt D'Arcy. (Courtesy of Gertie Brooks.)

It is hard to imagine a posse out of the frontier days would be a part of Lapeer County. Flags, wheelchairs, and drunk and disorderly people are some of the problems the posse has encountered, but they are ready to ride whenever the command is given. From left to right are Ed D'arcy, Ken Barkhouse, Robert Warren, Ron Randall, Keith McGregor, unidentified, Larry Wallace, Dr. Bill Mackie, Dr. John Thompson, Det Steward, and Red Brooks. (Courtesy of Gertie Brooks.)

Posse members are special deputies, but they do not carry revolvers. They hold business meetings monthly and have drills twice each month. The highlight of the year is a five-day campout in northern Michigan. From left to right are Ron Randall, Red Brooks, Bob Warren, Sam Heron, Dr. Mackie, Dr. Thompson, Ed D'Arcy, Wilbur Hunt, and Geo Hunt. The person presenting the trophy is unidentified. Lee McInnes (fondly nicknamed "Little Pants") is receiving the trophy. (Courtesy of Gertie Brooks.)

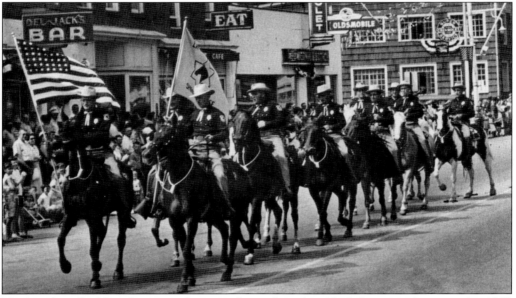

Hard-working Red Brooks carries the posse flag and is riding Trick, his trusty horse, in this 1960 Almont Heritage Festival parade. Riders and horses practice parade routines twice a month for parade duty to get the horses to respond to different commands and carry out complicated choreography. The posse has appeared in parades at Imlay City, Capac, Ortonville, Davison, Lapeer, and Dryden. (Courtesy of Gertie Brooks.)

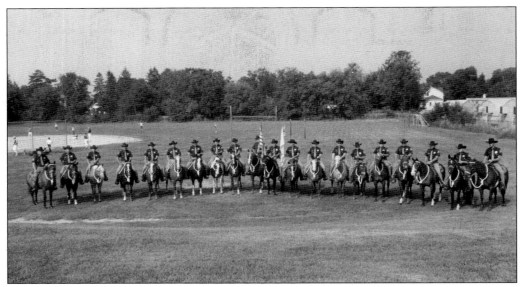

The Posse consisted of 24 members by 1984. They mount up at a moment's notice for rescue missions, directing traffic, and aiding in crowd control. The 24 members, only 20 of whom are pictured here, are Chuck Schumck, Bill Townsend, Tim Hunt, Sam Mendola, Fred Lovasz, Paul Brinker, Wilbur Hunt, Sam Heron (co–drill captain), Jerry Reinhardt, John Thompson, Det Steward, Larry Potter (co–drill captain), Red Brooks, Gene Waterson, Jack Miller, Jack Cross, Daryl Hunt, Ron Randall, Frank Conley, Larry Williams, Daryl Hunt (president), Tim Hunt (vice president), Bill Townsend (secretary), and Larry Williams (treasurer). (Courtesy of Gertie Brooks.)

Glenn Crawford was the youngest child of Martin and Ida Crawford, born in 1913. The St. Louis Cardinals signed him in 1937. Crawford performed a "hit around the horn," which was a single, double, and triple topped by a home run in one game, and became an All-Star shortstop. He was then traded to the Philadelphia Phillies. Crawford was the only man in Lapeer County to play in the Major Leagues and lived in North Branch all his life. (Courtesy of Fred Crawford.)

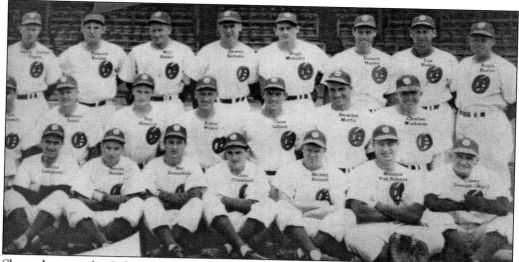

Shown here are the Oakland Oaks of the Pacific Coast Baseball League in 1947. Glenn Crawford is sitting in the first row, fourth from the left. Crawford held manager Casey Stengel (first row, far right) in high regard. Crawford said of the sport, "once baseball really gets under your hide like it has with me, there isn't much any guy can do about it except to stay in there swinging and loving it." (Courtesy of Fred Crawford.)

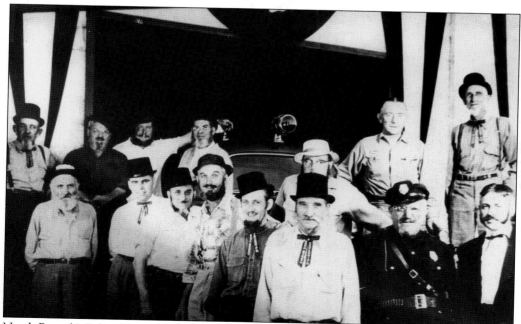

North Branch's Police Centennial of June 1955 features from left to right: (first row) Jack McCurdy, Bob Soldan, Art Podvin, George Stelmak, Keith Bennett, Sandy Rutledge, Chief of Police Ralph Knack, and Jim Scrimger; (second row) Chief Carl Bennett, Assistant Chief Lew Michaell, Earl Bennett, Walter Foster, Ken McIntosh, Harry Chambers, and secretary and treasurer Zeno Mack. (Courtesy of NBHS.)

North Branch was settled in 1854 near two Indian villages and began hosting annual fairs in 1870. This centennial is honoring the pioneer spirit of North Branch and the brave servicemen in the 1940s. (Courtesy of NBHS.)

Pioneers used oxen to drive the wagons because oxen could forage in the woods and survive with little food. Settlers first built log shanties. The logs were laid one above the other, notched at the corners to fit snugly. The crevasses were filled or "chinked" with bits of wood and mud. The first births in North Branch were a daughter to Mr. and Mrs. Richard Beach and a son to Mr. and Mrs. George Simmons. The sign on the wagon reads "Lloyd Lake of Lakecroft Service." Lloyd's was located two and a half miles east of town. Lloyd was president of Michigan Milk Produce. (Courtesy of NBHS.)

Some of the Indians in North Branch purchased the land they lived on, as described in *Sesquicentennial North Branch 1855 to 1980*. Many Chippewas had several Indian communities east of the town of North Branch. Simmons's land bordered one of the Indian villages, so Indian Jim requested that Simmons's son be named Jim in honor of the Indian chief. The Simmons complied willingly. (Courtesy of NBHS.)

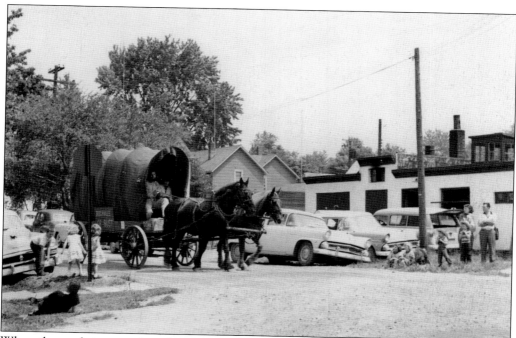

When the roads improved, settlers preferred horses for travel. The pioneers brought with them what they would need to build and live on in their wagons. The sign on the side says "Beechville or Bust." Beechville was the first name given to this region. Later it became known as North Branch. This wagon is a Steudebaker that was owned by P. Orr. It is on display at the Orr Museum. (Courtesy of NBHS.)

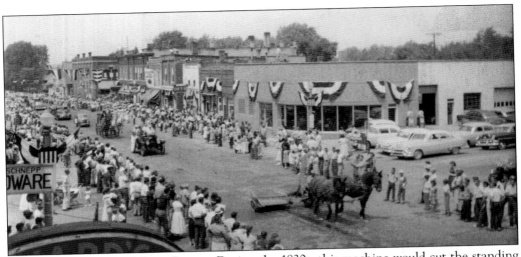

A horse is pulling an Osborn Reaper. During the 1830s, this machine would cut the standing grain and with a revolving reel, swept it onto a platform where it was raked off into piles by a man walking alongside. Reapers harvested more grain than five men could using the earlier cradles. Osborn and McCormick got into a patent lawsuit during 1934, and McCormick won. (Courtesy of NBHS.)

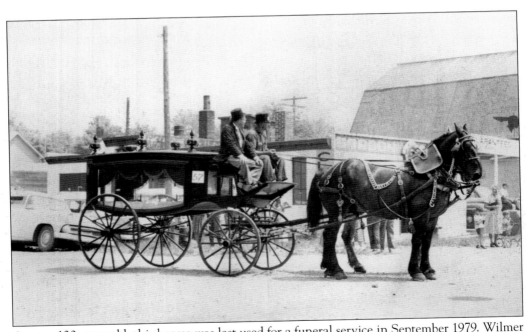

At over 100 years old, this hearse was last used for a funeral service in September 1979. Wilmer Fricke is driving Blackburn's hearse. He married into the family and ran the business on Stanley's death in 1965. In 1977, Fricke donated the ambulance car and lifesaving systems to North Branch. He retired in 1985 and sold Blackburn to Karl D. Walls. Walls sold it to Patrick Martin in 1993. The Blackburn Chapel–Martin Funeral Home then went to Martin's son, Kelly Martin, and as a result is one of the oldest funeral homes in the state of Michigan. (Courtesy of NBHS.)

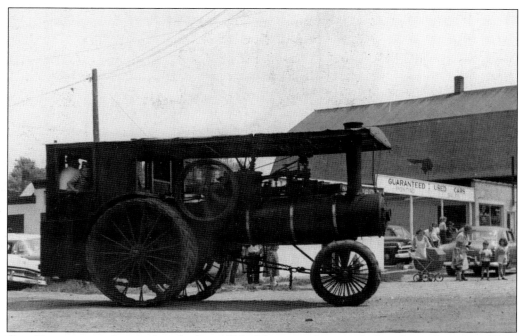

Cass Tractors were first used in the late 1800s. They were large and often driven by steam. They could pull as many as 40 plows across a field at one time, but often were too big and awkward to be practical. (Courtesy of NBHS.)

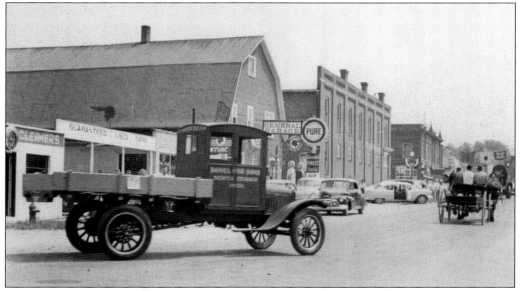

In September 1975, the community of North Branch held Daniel Orr Sons Day for their 100 years of community service. Throughout the years, the Orrs acquired hundreds of historical artifacts. They began North Branch's Orr Museum, the largest privately owned museum in the state. The museum is divided into six areas: hardware, blacksmith, woodworking, plumbing, tinsmith, and household. This 1923 pickup truck is exhibited, as well as horse-drawn vehicles, a wagon-wheel reamer, and more. (Courtesy of NBHS.)

The Cub Scouts are an important institution for young boys to learn the art of camping and living off the land. Dwight Preston Orr was the first Boy Scout leader in North Branch. He was also a director of the Pioneer Bank that started in December of 1879. Dwight was also a member of the village council. He was born in North Branch on December 4, 1888, and died October 18, 1972. (Courtesy of NBHS.)

North Branch celebrated the nation's independence on the Fourth of July in a three-day 1940s tribute to the brave men fighting in the war. World War II opened the Atomic Age and brought sweeping changes to the world. In 1940, a county draft board was named. (Courtesy of NBHS.)

World War II began for the United States on December 7, 1941, with the bombing of Pearl Harbor. During the war, farm boys served in the foxholes next to seasoned soldiers. Food, rubber, and gasoline were rationed, but Americans did not mind. They were helping their sons, husbands, and sweethearts fight the battle for freedom. (Courtesy of NBHS.)

During President Roosevelt's radio broadcasts, he urged Americans to help the war effort by purchasing war bonds. War posters advertising bonds quickly followed. An all-out effort to manufacture planes, tanks, and ammunition correctly the first time was driven home to the women and men working the assembly lines because servicemen's lives were on the line. (Courtesy of DHS.)

"God help me if this is a dud!"

HIS LIFE IS IN YOUR HANDS

The Nazi swastika sent a cold chill through Europeans and Americans. Newsreels of the front lines flooded the movie houses. Portrayed here is a German soldier stabbing the Bible. As told in *Pioneer Families and History of Lapeer County*, when the invasion of Europe started on June 6, 1944, $300,000 of war bonds were sold in that single day. (Courtesy of DHS.)

THIS IS THE ENEMY

CARELESS TALK ...got there first

"Loose Lips Sink Ships" was one of many popular slogans. Servicemen were cautioned not to write home about their next mission. Loved ones were warned not to say anything that could jeopardize a serviceman's safety. The Citizens Service Corps, part of the local Defense Council, had war tasks for everyone. As told in *Pioneer Days and Early Ways*, the American source of kapok, a light, water-resistant, and buoyant fiber, was shut off during the war; boys and girls ran out to the marshlands to collect floss from the milkweed pods needed to make "Mae West" life jackets. (Courtesy of DHS.)

Freedom was not free during the 1940s, as this "Service above Self" float says. The Allies called World War II "a war of survival." President Roosevelt died on April 12, 1945, and a sorrowful nation mourned his loss. Germany surrendered on May 7 and Japan on August 14. (Courtesy of NBHS.)

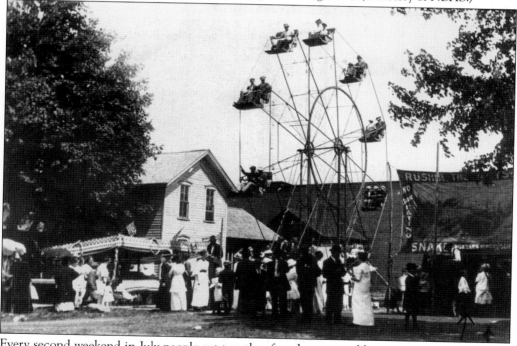

Every second weekend in July people get together for what some older citizens continue to call a homecoming and what newcomers call a festival. This is Columbiaville's homecoming during 1913. The homecoming took place at the corner of First and Middle Streets. The present festivals occur on Main Street, complete with parades and marching bands. (Courtesy of CHS.)

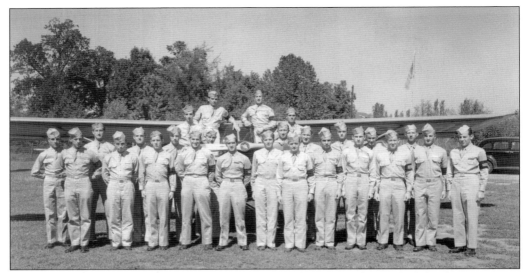

Columbiaville's Ron Seamers is seen here during World War II second from the left. This picture was taken at the US Army Air Cadets Pilot Training School, Southern Aviation Corp in Murfreesboro, Tennessee, around 1943. The plane is an Aeronca 65-TL. (Courtesy of CHS.)

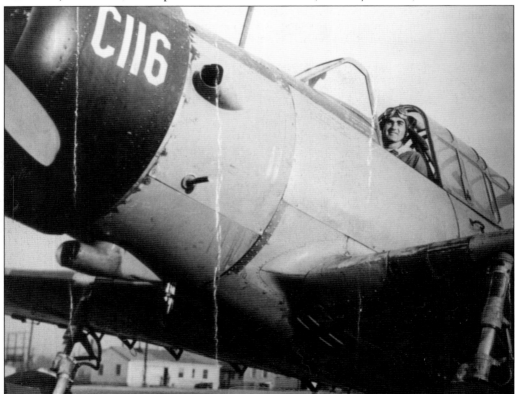

Columbiaville Lt. Carl Hibbert is visible in the cockpit of a Vultee BT-13 Valiant. This was a two-seat training airplane in 1943. Hibbert became a copilot of a B-17 Flying Fortress in 1944. (Courtesy of CHS.)

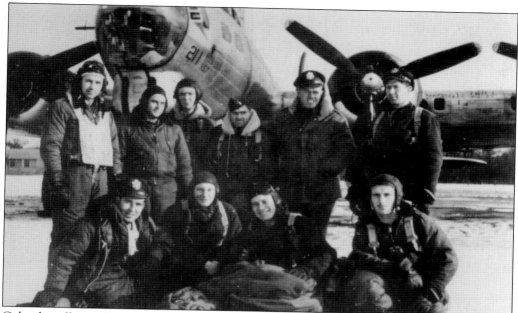

Columbiaville copilot Lt. Carl Hibbert is pictured standing second from right in the second row with his crew. This is a Boeing B-17 bomber, known as the Flying Fortress. It carried a 10-man crew and had a top speed of 313 mph. The B-17 could travel to England in just over eight hours. (Courtesy of CHS.)

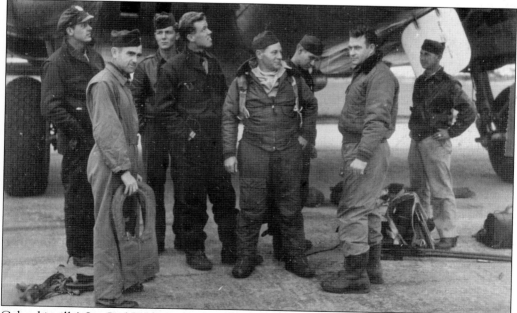

Columbiaville's Lt. Carl Hibbert stands at front left with his crew, back from a rough mission in 1944. In Hibbert's honor, the Veteran's Memorial Park stands as a lasting reminder of all World War II veterans' sacrifices. The park overlooks Holloway Reservoir and is adjacent to the Southern Links trail on 4730 First Street. It is located next to the Columbiaville Museum, Historical Society, and Community Center. (Courtesy of CHS.)

Discover Thousands of Local History Books
Featuring Millions of Vintage Images

Arcadia Publishing, the leading local history publisher in the United States, is committed to making history accessible and meaningful through publishing books that celebrate and preserve the heritage of America's people and places.

Find more books like this at
www.arcadiapublishing.com

Search for your hometown history, your old stomping grounds, and even your favorite sports team.

Consistent with our mission to preserve history on a local level, this book was printed in South Carolina on American-made paper and manufactured entirely in the United States. Products carrying the accredited Forest Stewardship Council (FSC) label are printed on 100 percent FSC-certified paper.

MADE IN THE USA